W9-BNB-613

Artists in Focus

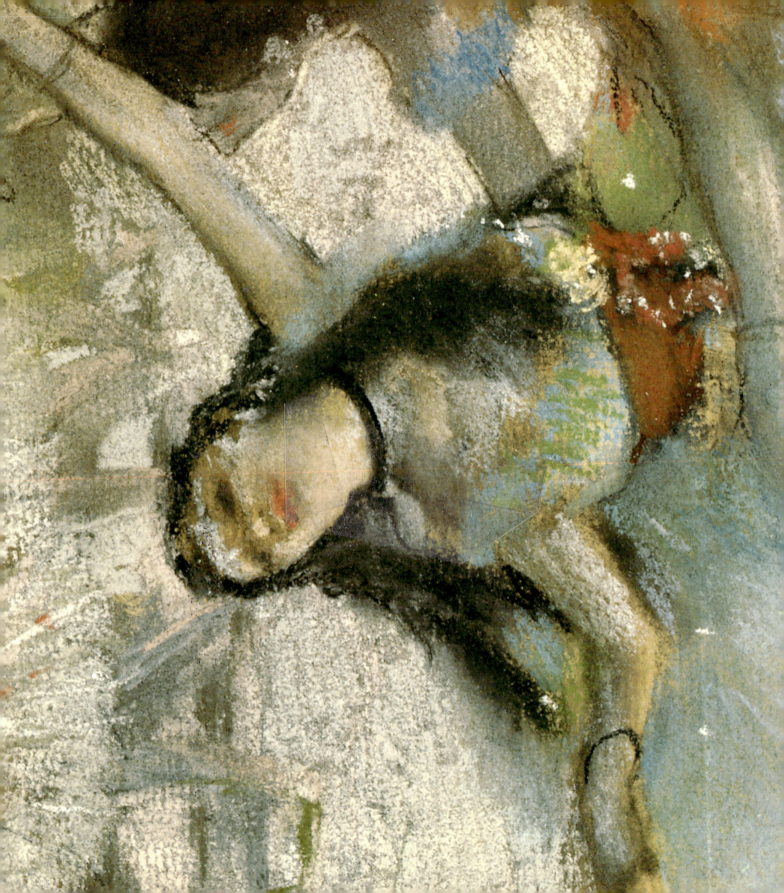

Degas

Jean Sutherland Boggs

THE ART INSTITUTE OF CHICAGO

Distributed by Harry N. Abrams, Inc., Publishers

Produced by the Publications Department of The Art Institute of Chicago, Susan F. Rossen, Executive Director
Edited by Susan F. Rossen and Britt Salvesen in consultation with Douglas W. Druick
Production supervised by Daniel Frank and Sarah Guernsey

Designed and typeset by Joan Sommers Design, Chicago
Color separations by Professional Graphics, Inc., Rockford, IL
Printed and bound by Mondadori, Verona, Italy

Distributed in 1996 by Harry N. Abrams, Inc., a Times-Mirror Company, 100 Fifth Avenue, New York, NY 10011

Library of Congress Catalog Card Number 96-85474

ISBN 0-8109-6324-8

Photography, unless otherwise noted, by the Department of Imaging and Technical Services, Alan B. Newman, Executive Director

All figures and plates illustrate works by Degas in The Art Institute of Chicago, unless otherwise noted. Dimensions of works of art are given in centimeters, height preceding width.

Fig. 1: photo by Martin Bühler. Figs. 2, 7, 9: All rights reserved, The Metropolitan Museum of Art, New York. Figs. 3, 18: photo © Bibliothèque nationale de France, Paris. Figs. 4, 10, 11: photo © R.M.N. Fig. 5: Courtesy the Trustees of the National Gallery, London. Fig. 14: from Ottawa, National Gallery of Canada, et al., *Degas*, exh. cat., 1988, p. 344. Fig. 16: photo by Luiz Hossaka. Fig. 17: All rights reserved, Document Archives Durand-Ruel, Paris.
Cover: Edgar Degas, *The Star*, c. 1880 (pl. 21)
Details: frontispiece (see pl. 12), p. 15 (see pl. 3), p. 27 (see pl. 9), p. 33 (see pl. 11), p. 43 (see pl. 20), p. 49 (see pl. 21), p. 53 (see pl. 24), p. 59 (see pl. 30), p. 67 (see pl. 34), p. 71 (see pl. 23b), p. 106 (see pl. 13)

Contents

Foreword

The Art Institute of Chicago's holdings include more than ninety works by Edgar Degas in a variety of media, spanning his career from the mid-1850s to the turn of the twentieth century. *Degas* is the second title to be published in the Art Institute's series *Artists in Focus*, which features individual treatments of key modern artists who are particularly well represented in the museum's permanent collections. Like its predecessor, *Monet*, by Andrew Forge, the present volume celebrates the work of a highly individual and much-admired artist; and, at the same time, displays the incredible diversity of aim, technique, temperament, and style that have made French Impressionism such a compelling subject of both aesthetic contemplation and rigorous scholarship. Degas distinguished himself from his contemporaries in part by his daring and innovative technique. The artist's

preferred subject matter is now familiar but never clichéd; his dancers, jockeys, singers, and bathers are dynamic testaments to his exploration of the relationship between his manual activity and the physical activity of his models. He could also be clearly sensitive to the mental activity of his sitters, as revealed in the subtle domestic portraits of his early years.

Since Degas was first and foremost a draftsman, it is fitting that the first works by him to enter the museum (in 1921) were works on paper. It is also appropriate, given Degas's relentless experiments with media and commitment to subjects of modern-day life, that it was in 1933, the year of the "Century of Progress" exhibition held at the time of the 1933–34 Chicago world's fair, that the museum received two very important paintings, *Uncle and Niece* (pl. 9) and *The Millinery Shop* (pl. 24), through the

generous bequest of Mr. and Mrs. Lewis Larned Coburn. At this time, the collections were reinstalled to reflect the history of Western art, and one gallery was dedicated exclusively to the art of Degas and Monet.

In 1984 the Art Institute marked the 150th anniversary of Degas's birth with an exhibition and publication of his work in our collections. Since that time, the art of Degas has continued to generate a high level of scholarly research, encompassing the areas of technical, sociological, and aesthetic analysis; hence, our wish to take a fresh look at these images, and at works acquired in the intervening years. Published to coincide with the Chicago showing of the exhibition *Degas: Beyond Impressionism*, in which the artist's late works are given long-overdue attention, this book, written by leading Degas expert Jean Sutherland Boggs, surveys the artist's career

and practice. Miss Boggs has made extensive contributions to Degas scholarship as an author, professor, curator, and museum director. She has concentrated on individual media in studies of his drawings and pastels, and has analyzed his approach to particular genres, such as portraiture. Perhaps most impressively, she presented Degas's oeuvre in all its range and depth in her role as the coordinator of the landmark Degas retrospective exhibition held in Paris, Ottawa, and New York in 1988. We are pleased that she has brought the distinction of her scholarship to the Art Institute's collections.

James N. Wood, Director and President
The Art Institute of Chicago

rom his work, we would expect Edgar Degas to be the most French and even the most Parisian of men. Indeed, he was born (in 1834) and died (during World War I, in 1917) in the same section of Paris, just below Montmartre. His names, however, tell us more. We know from his birth certificate that he was called Hilaire Germain Edgar: Hilaire after his paternal grandfather, Hilaire (or, in Italian, Ilario) Degas of Naples; Germain after his maternal grandfather, Germain Musson of New Orleans; and finally Edgar, because it struck his parents' fancy. His grandfathers were adventurers. Hilaire Degas, from a family of bakers in or near Orléans, made his way during the French Revolution from Paris to Naples, where he became a banker and established himself in his own eighteenth-century palazzo. Germain Musson was born in the French colony of St.-Domingue, which he left six years after a revolution changed it into independent

Haiti. He settled in New Orleans, where he prospered as a merchant. Although Musson took his children back to France to be educated, he did not remain there himself, and he finally died exploring for silver in Mexico. The painter inherited the independence and courage of his grandfathers, although he channeled it in a different direction.

Something of the character of Edgar's father is indicated by his own name, Auguste De Gas. The family name had always been spelled as one word; we know it best from the red "Degas" stamped on the artist's works that were sold after his death. When Auguste moved from Naples to Paris to establish a branch of his father's bank there, he decided to divide the name into the more socially acceptable "De Gas," in which the particle "De," like "von" in German, indicates land ownership. This was the form used by Edgar and his four siblings until the painter, in the early

1870s, stopped signing "De Gas" and instead wrote "Degas" like his Italian relatives. The others in France continued to use "De Gas," with the exception of René, the youngest, who much later, and quite dishonestly, decided to make it "de Gas," with its aristocratic pretensions. He had inherited their father's tendency to prefer appearances to reality.

Auguste decided that Edgar, as the eldest, should not only receive a good classical education as a boarder at the Lycée Louis-le-Grand, in Paris, but should also study law, presumably in order to become an efficient head of the family's small Parisian bank. Although Edgar did enroll in law school, he scarcely persevered and may never even have attended classes. By nature as incapable as his father would prove to be of handling business affairs, he began to study art, but in a somewhat unconventional manner. Upon graduation from the lycée, in 1853, he

registered in both the department of prints at the Bibliothèque nationale and the department of drawings in the Musée du Louvre, so that he could make copies after the works of other artists. He also attended classes in certain painters' studios, where models were provided but very little instruction. Although he was accepted as a student at the Ecole des beaux-arts, there is no record of his attendance or even of the studio to which he was assigned.

While undirected, Degas was nevertheless not idle in the three years following his graduation from the lycée. Although his father hoped he would choose another career, he did take him to see some of the great private art collections in Paris. It was from his father too that Edgar learned to love the theater and music, which were to become as important for his work as for his leisure. The Degas home seems to have been a sympathetic environment for Edgar's

home more often to serve as a model. In any case, Degas, in the mid-1850s, executed at least two paintings and numerous drawings of the child. In the Art Institute's collection, there is a study in chalk of his profile (pl. 1). It is a serious, disciplined drawing that, as if in relief, comes to life because Degas allowed himself to swagger a little in describing the curves at the back of René's head and the weight of the locks over his forehead. He also nicely accented the nostrils, mouth, and throat. The boy's uplifted face, parted lips, and raised brows indicate interest in something beyond himself. Probably working from a reproduction, Degas based his drawing on the profile of the young boy with the ragged mop of hair in a painting by Hans Holbein the Younger, *The Artist's Family* (see fig. 1). Degas made his brother's hair thicker and more uneven, stubbing his nose and rounding his features, but he captured the expression of longing of Holbein's son. The Northern Renaissance artist's moving panel of a tearful mother with two melancholy children has often been interpreted as revealing the unhappiness of his family during his long absence in London, when he was court painter to the English royal family. René's blank eyes may reveal his need for the unknown mother who had died when he was a baby.

When Degas went to Italy in 1856, he did not simply trade the family hearth in Paris for his

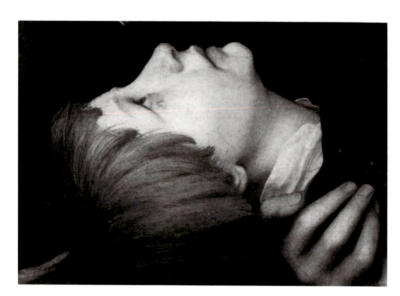

1. Hans Holbein the Younger (German; 1497/98–1543). *The Artist's Family* (detail), 1528(?). Distemper on paper, mounted on limewood panel; 77 × 64 cm. Oeffentliche Kunstsammlung Basel, Kunstmuseum.

development as an artist. His two younger brothers and two younger sisters often served as his models. In contrast to the faint copies of works by other artists and the almost monochromatic sketches of landscapes and buildings that he made in small notebooks while studying and traveling, Degas's paintings, drawings, and etchings of his family were assured and affectionate.

Degas seems to have been fondest of his youngest sibling, René, who was only two when their mother died in 1847, which must have made the painter feel particularly responsible for him. As the youngest, René could also have been at

grandfather's in Naples or his aunt Laure Bellelli's in Florence. Instead, he chose to stay in Rome, making sporadic visits to his relatives and going on jaunts with artist friends through the Italian countryside. Even though he never won a Prix de Rome, we know that he attended life classes at the Académie française at the Villa Medici, because he often made drawings there, which he inscribed "Rome." Such is the case with a charcoal drawing at the Art Institute, *Italian Head* (pl. 2), a study of one of the Académie's professional models.

The subject seems a vigorously healthy man, his hair electric, his nose boldly crooked, his shirt opened to reveal a strong neck. He is also not without intelligence, which is suggested by the light that falls on the forehead and continues along the nose; glows below the pale, but speculative, eyes; and touches the lower lip of the small and sensitive mouth. The bold handling of the charcoal and blurring of the transitions create a powerful sensation of sculpture in the round, in contrast to the delicately handled chalk drawing of René, which reads as a relief. As the model turns away from us, most of his head is veiled provocatively in shadow. Like many of the drawings Degas made in Italy, and in accord with common practice, this study would have been a preparatory exercise for the history paintings that

were still considered the test of artistic achievement in the academies and salons of the time.

Degas worked on what became an autobiographical study during and just after his Italian stay: an etched *Self-Portrait* (pl. 3; detail p.15) that went through four states in which the image was changed by successive manipulations of the copper plate. The first two states were probably made in 1857, when the twenty-three-year-old Degas was largely living in Rome and coming to know other expatriate artists such as Gustave Moreau and James Tissot, and Italians such as Telemaco Signorini. In the etching, a standing Degas presents himself with apparent candor, wearing a soft hat and a dark coat, attire that may appear almost nattily formal now but was conventional for an artist venturing to work out-of-doors in the mid-nineteenth century.

In the first state of the etching, Degas drew with a needle on the waxed plate with such delicacy and restraint that the entire image seems a cobweb of lines that only survives in the third state in the modeling of the face. In the second state (fig. 2), he strengthened the image, making himself somewhat more assertive. Although understated, there is a certain arrogance in the raised brows, in the eyes that refuse to meet ours, and in the pouting lips. This would have been much increased had he linked his eyes and mouth with a clearly delineated nose, but instead

etching, with a shiny top hat in his hand. Unlike the etching, the photograph indicates a seemingly contradictory combination of physical lassitude and nervous tension, the latter quality conveyed to some extent by the clenched left hand, but even more by the intensity of the facial expression. In comparison with the etching, the shadows under and around Degas's eyes in the photograph are darker, and the jaw is thinner, so that the line of the nose, extending from a dark area over his brow and continuing down into the dense mustache and beard, gives him the physiognomy of a ferret or a fox. The photograph reveals that Degas was neither as much at ease with himself nor as composed as he appears in his own etching. But it does not belie his determined will.

We know that Degas made the third state of the etching (pl. 3) after his return to France in 1859, since the paper on which it was printed has a watermark not used before 1860. Here he strengthened the etching by darkening the hat and coat to the point that they look opaque. He also reinforced the features of the face so that the eyes are softer and blacker, the eyebrows more decisively arched, and the mouth fuller and more sensual, emphasized by the darker mustache and beard. The hair and beard appear windblown. In this more romantic head, however, the brows remain sufficiently quizzical, the eyes sufficiently shadowed, and the mouth sufficiently petulant

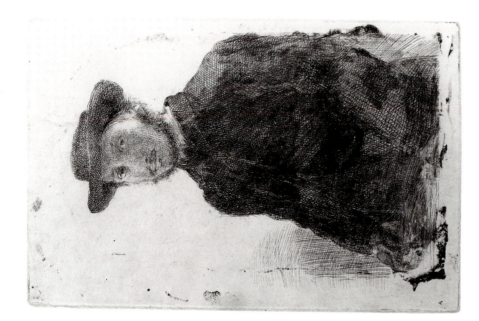

2. *Self-Portrait*, 1857. Etching and drypoint, second state of four; 26 x 18.2 cm. The Metropolitan Museum of Art, New York, Jacob H. Schiff Fund, 1922.

he left the nose so light that we must imagine it. In fact, the intense Roman sunlight—indicated by the blank paper—plays an important role in this state of the etching, threatening to dissolve the figure entirely. But Degas is steadfast, inviting neither our admiration nor our compassion.

A photograph exists of Degas at this time, made by an unknown photographer (fig. 3). In it, the painter wears more formal clothing and stands, in much the same position as in the

that Degas still seems vulnerable in spite of the self-possession of his demeanor. The influence of the art of Rembrandt van Rijn is apparent in the head and hat, but even more so in the turbulent, almost abstract, background, achieved with washes of acid, which seems to express the young artist's unrealized longings.

In the fourth state of the print (not illustrated here), Degas cleared away the theatrical lights and darks of the third, creating a more focused, urbane, and cynical image of the artist. The four states, in addition to showing the development of Degas's attitude about himself at the end of his stay in Rome and in the first months in which he was adjusting to life in Paris after returning from Italy, also show how relentless the artist could be in producing radical variations on his own work. This would continue throughout his career. He would always be a tinkerer, someone who could find new possibilities in traditional media and techniques—fresh wine in old bottles—and be ready to produce transformations, even of those works painted, etched, or drawn many years before.

When Degas sailed for Marseilles from Genoa in 1859, he must have looked very much like the self-portrait he had etched two years before. Although he had already shipped paintings back to his father in Paris, he probably carried with him the studies he had been making in Florence for the portrait of the family of his

aunt Laure, *The Bellelli Family* (fig. 4), which he would finish in Paris. Also with him were some nine small notebooks of studies—copies, landscapes, drawings from life, portraits, architectural fragments, etc.—which indicate the range of his interests over the Italian years but also contain notations he could develop later into more finished works of art. They make it apparent that Degas did intend to compete in the forum provided by the annual Salon, the prestigious

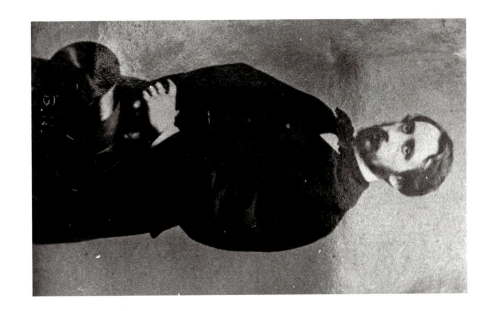

3. Anonymous. *Edgar Degas,*
c. 1855/60. Photograph printed
from a glass negative.
Bibliothèque nationale, Paris.

In this more romantic head, . . . the brows remain sufficiently quizzical, the eyes sufficiently shadowed, and the mouth sufficiently petulant that Degas . . . seems vulnerable in spite of the self-possession of his demeanor.

4. *Family Portrait (The Bellelli Family)*. 1858-67. Oil on canvas; 200 x 250 cm. Musée d'Orsay, Paris.

between the two canvases is a gap of two decades, which makes the four years during which Degas etched his *Self-Portrait* seem insignificant. X-rays of the London canvas have revealed very few differences between it and the painting in Chicago, other than the omission of any architectural details and a subtle, but significant, transformation of the neoclassic Spartan youths into contemporary street urchins of Montmartre.

The Chicago canvas, a rarefied evocation of ancient Greece, represents Degas's original conception. An apparently thin but mat oil sketch, it was executed almost entirely in a faint pink with black lines, except for a sea of pale green roofs that seems to be a reconstruction of Sparta, reminiscent of the artist's vision of an ancient city in his almost contemporary painting *Semiramis Building Babylon* (Musée d'Orsay, Paris). The specific meaning of the subject of *Young Spartans* has been a matter of some dispute and even greater hesitation. Although Degas could be frankly derivative in his renderings of the past, no single, clear literary or pictorial source has been discovered for this subject. Now it is generally assumed that its purpose was less archeological than anthropological, an embodiment of a rite of passage in adolescence, as is suggested by the title Degas intended to use for London's version in the 1880 exhibition, *Young Spartan Girls Challenging Some Youths*.

official art exhibition held in Paris. Upon his return to France, he did execute some history compositions and actually selected one of them, *Scene of War in the Middle Ages* (Musée d'Orsay, Paris), as his first submission to the Salon, in 1865.

The Art Institute of Chicago is fortunate to have a version of one of Degas's most important history themes, *Young Spartans* (pl. 4), painted around 1860. The final version of the subject, now in London (fig. 5), was dated 1860 by the artist when, in 1880, he decided to exhibit it in the fifth Impressionist exhibition. It is now generally agreed that London's version, which is only slightly larger than Chicago's, was reworked about the time of the 1880 exhibition. Thus,

Degas was often drawn to depict children in puberty. He had observed his brother Achille and his sisters pass through this stage of development before he left for Italy, and he could study it on his return in fourteen-year-old René. It should be pointed out that Degas's interest in the young was not directed toward those as youthful as the little girls who attracted his brilliant contemporary in England, Lewis Carroll, nor was it as obsessive. Degas enjoyed the awkwardness of adolescents, as well as their unexpected revelations of grace; and, above all, he relished the

potential that both suggest. In spite of the brief, draped skirts and Phrygian caps worn by some of the girls in the painting, both boys and girls are in positions that seem completely natural and that do not conceal their nascent sexuality. The painter did not hesitate to show physical affection between the two girls behind the two figures in front.

In drawing and painting the figures, Degas distinguished genders not only through anatomy but also through activity. Compared to the girls, the boys engage in more strenuous and apparently

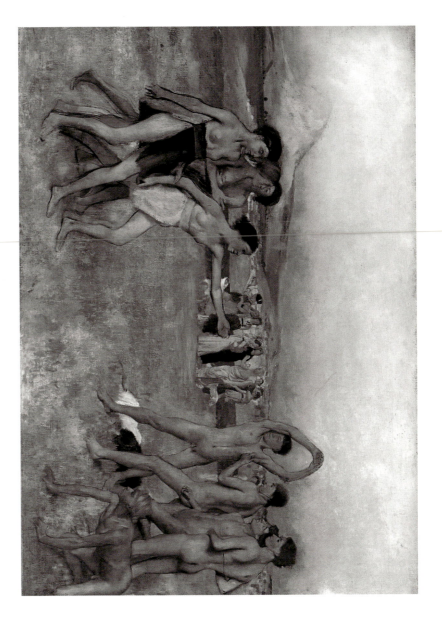

5. *Young Spartans*, 1860/80. Oil on canvas; 109 x 155 cm. National Gallery, London.

17

motiveless activities for their own enjoyment: one boy stretches upward, another drops on all fours. They are restless and somewhat haphazardly assembled. The equal aimlessness of the girls seems to come from a certain shy reluctance, as expressed by the figure at the left. They are more intimate with one another, the two in the foreground clasping each other's hands, the other pair whispering. But when one of them acts, like the girl who extends her arm, the movement is a simple, directed provocation.

Typically, Degas's history paintings tend to read like friezes—from one side of the composition to the other—but *Young Spartans* was composed around a central axis and is remarkably symmetrical. The ground plane is not as perspectively consistent as the floors would be in Degas's later interiors; but, like a stage, it nevertheless supports the two groups of figures in the foreground and the cluster of mothers behind them. The drama is subdued, even frozen, by the clarity of the outlines defining the bodies, as well as by the decisiveness with which the girls are separated from the boys and both from their elders. Charming as the young Spartans are, they remain symbols. We never expect the boys and the girls actually to meet.

Curiously, Degas's life between 1859 and 1865 is relatively undocumented. We know where the artist lived and worked, for the most

part; that, in these years, he painted his major history paintings as well as *The Bellelli Family* (fig. 4); and that both his sisters married. But we cannot trace the exact chronology of his activities. We do know, however, that he emerged in 1865 as a self-reliant human being and maturing artist. While he submitted works to the Salon until 1870, his art was moving in a direction that would make a rupture with that official body inevitable. He was also gradually becoming friendly with artists who would show a similar independence.

In the mid-1860s, Degas turned to subjects from contemporary life. For example, the Art Institute's 1865 wash drawing *Mme Michel Musson and Her Daughters Estelle and Désirée* (pl. 5), is an important record of his relationship to his mother's family. By the time of the death of his grandfather Germain Musson, Degas's aunts and uncles largely lived in France. One exception was the eldest Musson son, Michel, whose business interests grew out of his father's in New Orleans. In the early 1860s, Michel's work and family were suffering from the effects of the American Civil War. Consequently, he sent his wife, Odile, to France with two of their three daughters, Désirée (who never married) and Estelle Balfour (whose husband had been killed in the battle of Corinth, Mississippi), as well as Estelle's infant daughter, Joe. For reasons of health, they settled in Bourg-en-Bresse in Burgundy. The painter visited them

there for the Feast of the Epiphany, January 6, in both 1864 and 1865. From Désirée's description of his 1865 visit, it is quite clear that Degas was welcomed by these women, who must have been lonely and homesick for New Orleans. This drawing—in which we see Odile seated at the left, Désirée standing, and Estelle crouched on a stool in the center—records the second of these visits; Degas formally inscribed it at the top, "Bourg-en-Bresse, 6 janvier / 1865 / E. [and still using his father's form of their name] De Gas."

Although it was to be a year or two before Degas made the few of his early paintings that are known to be after photographs, this drawing has the compositional formality of the already antiquated daguerreotype and the golden-brown tonality of many contemporary photographs printed on paper. Nevertheless, Degas used the tools of a draftsman: a pencil to draw with precision the features of the women's faces, the gestures of their hands, the folds of their dresses, and the ornament of the mantelpiece; a brush to apply washes directly for a subtle range of hues within the grayish browns; and black chalk and charcoal to add body to their hair. Although he did not flatter the three women, he made each convincing, gentle, and dignified. Estelle Balfour, in her widow's dress and seated on a stool in the foreground, particularly invites our sympathy, partly because of the very plainness of her oval

face. Degas described her in a letter of 1865: "As for Estelle, poor little woman, one cannot look at her without thinking that before that face are the eyes of a dying man." Estelle appealed particularly to René, then not quite twenty, who insisted on returning to New Orleans with the family. In 1869 he finally married Estelle, who by then was almost blind. It is hard to look at this watercolor without seeing in it the family's future tragedies, including serious financial tribulations and the desertion of Estelle by René. This makes a melancholy drawing more poignant still.

In spite of its photographic formality, the drawing of the Musson family expresses a naturalness and intimacy between the sitters that characterize Degas's portraits in the mid-1860s. One reason for his interest in intimate portraiture may have been the sympathetic society he was frequenting at this time, one of artists and senior civil servants such as the Manets and Morisots, to whose homes he was invited regularly, often with his father. These informal evenings—with music, gossip, and matchmaking—among people with a deep love of the arts, obviously gave Degas much pleasure. A key figure in this was Edouard Manet—already a great artist, handsome, alluring, and restless—whom Degas often drew, etched (see fig. 6), and painted in the period leading up to the Franco-Prussian War (1870–71).

In this circle were two women, Mme Lisle

little annoyed when a man I consider to be very intelligent deserted me to pay compliments to two silly women." On an earlier occasion, she had damningly written that "painting is the thing that interests Madame Loubens least." We know little about the two women. Mme Loubens, who was apparently a link between the Manet and Morisot households, is believed to have posed for the central figure (without a veil) in Manet's *Music in the Tuileries Gardens* (National Gallery, London). Of Mme (or Mlle) Lisle, we know nothing, except that she may have been Marie Lisle, a painter who exhibited at the Salons of 1869 and 1870.

Degas may not have shared Morisot's opinion of Mmes Lisle and Loubens. During the years in which he exhibited at the Salon, he painted portraits of a serious Victorine Dubourg (Toledo Museum of Art), also a painter and later the wife of the artist Henri Fantin-Latour; Joséphine Gaujelin, a dancer with elegant facial bones whose portrait (Isabella Stewart Gardner Museum, Boston) Morisot perversely described as "very ugly"; and a sober Yves Gobillard-Morisot (The Metropolitan Museum of Art, New York), one of Berthe's sisters. Degas hardly indulged these women, but he did not conceal his admiration for their integrity. For the portrait of Mmes Lisle and Loubens, who may have only known each other casually from these evenings, Degas made drawings of each of their heads in charcoal with

6. *Manet Seated, Turned to the Right.* c. 1864/70. Etching on ivory wove paper, third state of four; 19.5 x 12.8 cm (plate). 31.5 x 22.5 cm (sheet). The Art Institute of Chicago, Charles F. Glore Collection, 1958.12.

20

and Mme Loubens, of whom Degas painted a portrait (pl. 6), now in Chicago's collection. Berthe Morisot, a fine painter and a great beauty, who would marry Manet's brother, carried on, with her mother and her two sisters, a gossipy correspondence that is our source for relatively intimate information about the modest social world in which Degas participated. In 1869, for example, Morisot wrote to a sister: "Monsieur Degas seemed happy, but guess for whom he forsook me—Mademoiselle Lille [*sic*] and Madame Loubens. I must admit that I was a

pastel and inscribed their names as if he needed to remind himself who they were. The drawing of Mme Loubens (The Metropolitan Museum of Art, New York), who sits at the right in the painting, is somewhat blank and evasive but does suggest a certain calculation on her part in the raised brows and the sweetly formed mouth. In the clearly unfinished painting, the execution of this figure is not as precise, but as she leans forward, with her hands clasped and fingers anxiously clenched, her stocky body seems aggressive. Mme Lisle, on the other hand, folds her arms over her chest, and withdraws into her own speculations. The delicacy of her face is set off by the burst of pink paint behind her head. In a drawing of her alone (fig. 7), in which the head is beautifully situated at the bottom of the page, Degas studied her refined features and her jaunty hat. In addition to inscribing her name, he wrote: "The eyes—clear and gray." It is these eyes that he captured in the painting. They stare outward, forming a psychological link for us with the world in which Mmes Lisle and Loubens were transient visitors.

At this time, Degas paid particular attention to the environments—normally rooms—in which he found his sitters. Here, although much was scraped off or overpainted, it is not difficult to make out a simple version of a Second Empire interior. In short, it is domestic, probably com-

fortable, and unintimidating. But, as almost always in his double or group portraits, the character of the setting should come primarily from the relationship of the figures to each other and to us. In painting Mmes Lisle and Loubens, Degas must have sought for something more than the disinterest we find in this canvas. Although his preparatory drawings are confident, apparently he was never able to discover anything in painting the two women but their apathy. Probably bored himself, the artist left the painting unfinished. However, in revealing Degas's procedures and exposing his frustrations, the work is hardly boring for the viewer.

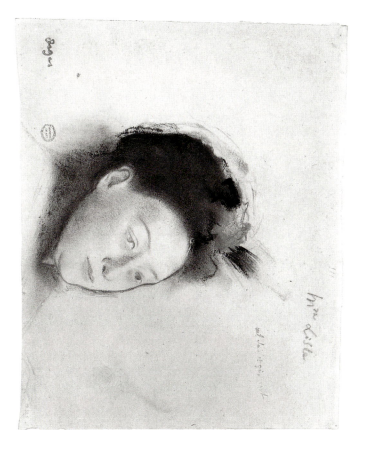

7. *Portrait of Mme Lisle*, 1866/70. Pastel and red crayon on buff paper; 22 x 25.7 cm. The Metropolitan Museum of Art, New York. Rogers Fund, 1918.

In about 1869, Degas began to paint out of doors. In the summer of that year, he made a series of gouache and pastel landscapes of the Normandy coast. At the same time, he became interested in horses, although he was apparently never attracted by riding, training, or breeding these animals himself. He had long copied horses by artists such as Alfred De Dreux, Eugène Delacroix, and Théodore Géricault, presumably thinking of their usefulness for history paintings; and indeed the horse plays a role in all of Degas's principal history paintings except *Young Spartans*. When he first visited the country house of a school friend, Paul Valpinçon, at Ménil-Hubert in Normandy, he not only discovered the animals on the farm but also the horses at a great breeding stable at nearby Haras-le-Pin. In Paris he started to go to the races at tracks such as Longchamp with his brother Achille, and with friends such as Valpinçon and Manet.

Between 1866 and 1868, Degas made several drawings of jockeys on horseback. The Art Institute has a particularly famous one, *Four Studies of a Jockey* (pl. 7). Essentially the sheet represents a single jockey, wearing the same silks, from four different angles, mostly from the rear, as he rides or prepares to ride. It has often been pointed out that the juxtaposition of four poses of a single figure and the nicety of their placement on the page give the drawing the assurance of one by the eighteenth-century master Jean Antoine Watteau. In addition, Degas added a certain rococo allure to the work, and demonstrated his liking for unusual media and materials, by staining the surface of the oiled paper irregularly with mat-brown, thinned oil paint (*essence*), so that the strokes of black gouache and blue and white oil paint stand out with a particular luminosity. Even more masterful is the easy binding together of the four views of the figure within one arbitrary frame. In each of the poses, the jockey sits solidly on his horse, but the animal is reduced to a few black lines.

In addition to drawing at the racetrack, Degas made studies at the steeplechase, at the hunt, and at informal gatherings of amateur horsemen. The Art Institute's *Gentleman Rider* (pl. 8), drawn by 1873, probably depicts one such amateur. As in *Four Studies of a Jockey*, Degas combined brush and ink with a more opaque medium; but here he depended more upon contour lines, which are brusque and interrupted. Whereas *Four Studies of a Jockey* limits us to a back view and only a glimpse of the profile in one pose, here we can enjoy the rider's strongly caricatured features, walrus mustache, and sloping chin, not to speak of a seated posture so rigid that an absurd accident seems a distinct

possibility. This drawing introduces us to the Degas of the 1870s, when his work—if not the man—could seem at its most lighthearted.

With the Franco-Prussian War (in which he, like Manet, had fought) behind him, Degas went to visit his two brothers and his uncle Michel Musson and their families in New Orleans during the winter of 1872–73. He was able to paint sun-filled canvases of his New Orleans relatives, including *Portraits in an Office (New Orleans)* (fig. 8), more familiarly, if incorrectly, known as *The Cotton Market*, and to contemplate the future direction of his work. As he confided to his friends, the trip was a watershed in his career. To the painter and printmaker James Tissot, who had left France for England, he wrote: "Remember the art of Le Nain and all medieval France. Our race will [also] have something simple and bold to offer. The naturalist movement will draw in the manner of the great schools and then its strength will be recognized."

After he returned from New Orleans to Paris in March 1873, Degas began to recruit artists for the independent exhibition that he, Monet, Morisot, and Renoir, as well as Cézanne and others (with varying degrees of commitment and responsibility), were planning to hold in 1874. He did not succeed, however, in eliciting support for the venture from Manet, who continued to show

in the official Salon. Not long before the opening of the exhibition, which later became known as the first Impressionist exhibition, Degas wrote again to Tissot (who did not agree to participate): "Look here, my dear Tissot, no hesitations, no escape. You must positively exhibit [with us].... Manet seems determined to keep aloof, he may regret it. Yesterday I saw the arrangements of the premises, the hangings, and the effect in daylight. It is as good as anywhere." He added, "The realist movement no longer needs to fight with the others, it already *is*, it *exists*, it must show itself as *something distinct*, there must be a *salon of realists*." Degas threw himself into the organization of these exhibitions in the 1870s (the first was held in 1874, the second in 1876, the third in 1877, and the fourth in 1879). This brought his work, which was witty, high-spirited, and full of surprises, to the attention of collectors, as well as caricaturists and critics, who could occasionally be cruel in print, so that Degas became something of a celebrity as a painter.

In contrast, he faced a number of personal trials, most of which were financial in nature. The Mussons in New Orleans (themselves in financial difficulties) had persuaded the Degas family to buy Confederate bonds. In addition, Degas's brothers, René in particular, had borrowed heavily from the family bank in Paris

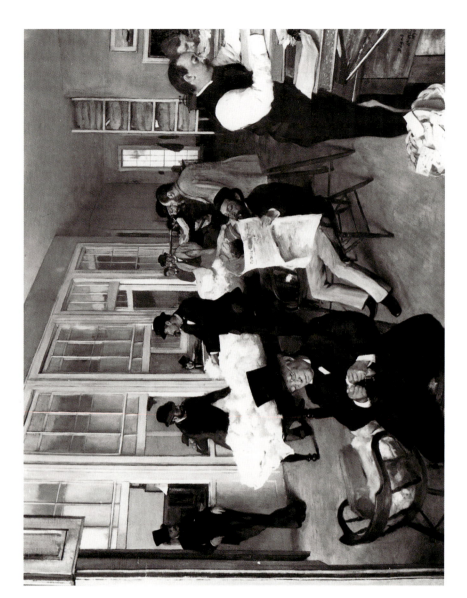

8. *Portraits in an Office*
***(New Orleans)*, 1873.**
Oil on canvas; 73 x 92 cm.
Musée des beaux-arts,
Pau.

to start their business in New Orleans. Even as Degas was painting *Portraits in an Office*, his uncle Michel, who is seen handling cotton in the foreground, was dissolving a partnership and essentially his business. Degas had written from New Orleans to a friend: "De Gas Brothers are respected here and I am quite tickled to see it. They will make their fortune." But his painting actually comments on his brothers' idleness: Achille lolls against a partition at the left, and René stretches out lazily as he reads a newspaper.

After Degas's return to Paris from New Orleans, his dealer, Paul Durand-Ruel, made some purchases of the artist's work which were to be his last for some years; he too was a victim of the general depression of the 1870s. The death of Degas's father, in February 1874, revealed Auguste to have been an incompetent businessman and a far-too-generous parent. His estate, to be divided among his five children, was estimated at only 4,918 francs. In actual fact, there were debts, and in 1877 a court order

against Degas and his brother-in-law Henri Fevre, the husband of his sister Marguerite, committed them to paying forty thousand francs to the Bank of Antwerp. Although the debt was repaid, and by the 1880s Degas was solvent again, the 1870s proved to be a period of real penury. In January 1877, one of his uncles wrote to his kin in New Orleans: "In Paris I see Edgar denying himself everything, living just as cheaply as possible. The seven Fevre children are dressed in rags. They eat only what is necessary." Degas was bourgeois enough to be ashamed of these circumstances and to snub a friend, the Irish author George Moore, as late as the 1890s because Moore made passing mention of them in an article on the painter.

To add to the financial problems—and, in some cases, partly because of them—there were other family embarrassments. In August 1871, Degas's brother Achille shot (but did not kill) his mistress's husband in front of the Bourse (Paris Stock Exchange), for which he finally served one month in jail. In February 1876, Degas and a maternal uncle had to commit another maternal uncle to a hospital for the incurably insane at Charenton. The greatest blow was probably the desertion by his brother René in 1878 of his blind wife and cousin, Estelle, of whom Degas was very fond, and their children in New Orleans. He eloped and married bigamously a neighbor who had been a reader to his wife. Although René and his new wife eventually settled in Paris, it was over a decade before Degas could forgive and see his brother.

We tend to measure Degas's work in the 1870s in terms of the first four Impressionist exhibitions, when his stage was certainly Paris. Nevertheless, he could not forget his American and Neapolitan connections. In the second Impressionist exhibition, in 1876, he chose to show two of the luminous canvases made during his stay in New Orleans, one of them *Portraits in an Office*, perhaps motivated by nostalgia for a paradise visited but now irretrievably lost. For Degas, Naples lacked the exoticism of New Orleans. With his father's death there, in 1874, and that of his uncle Achille one year later, it was necessary for the painter to go to Naples. In his will, Achille had provided for an orphaned niece, Lucie Degas, daughter of his brother Edouard, and left the remainder of his estate to the painter and his brother Achille, the uncle's namesake. Degas continued to negotiate over this property most of his life. In 1875 he was in Naples from February 28 through June, and again briefly in June 1876. It seems logical that it was on the first of these trips, which lasted four months, that he painted the Art Institute's *Uncle and Niece* (pl. 9; detail p. 27), when the uncle, Henri Degas, would have been sixty-six and Lucie eight.

Lucie is imprisoned in heavy, black mourning clothes, and her head is bent sadly. . . . The girl touches the back of her uncle's chair tentatively and deferentially.

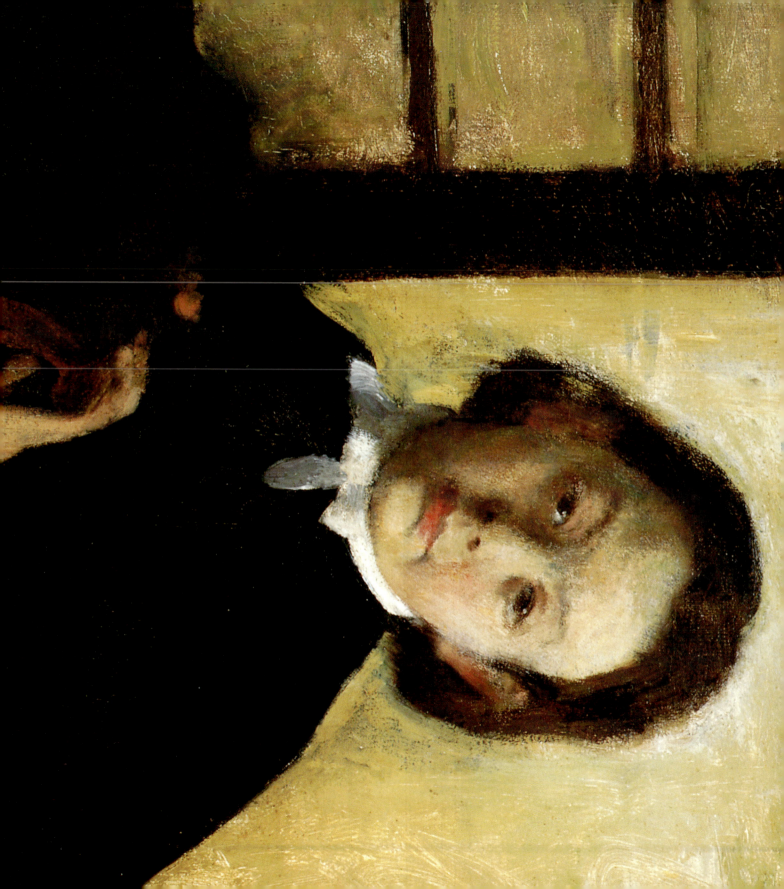

Henri had succeeded his brother Achille as guardian to Lucie, who had been orphaned at age three. Although passages of very pale gold on the wall and door soften the interior of *Uncle and Niece*, the room seems as hollow as the rest of the vast, underfurnished Palazzo Degas, in which Lucie had grown up. Papers and books appear more important in that austere environment than ornament or toys. In addition, Lucie is imprisoned in heavy, black mourning clothes, and her head is bent sadly, in a manner that many have likened to Italian Renaissance Madonnas and saints, in particular those by Perugino. The girl touches the back of her uncle's chair tentatively and deferentially. Uncle Henri, who has dropped the newspaper he has been reading and stopped puffing on his cigar, raises his head quizzically and not without humor. He appears a gentle, receptive man. But Henri was probably incapable of breaking through the trance of the palazzo, mourning, and Lucie's loneliness and melancholy. Their heads are almost—but not quite—parallel in the painting, which emphasizes their common helplessness and sorrow.

Paris fortunately provided a more animated and open setting for Degas. There may have been clashes and contradictions, tensions and confrontations, but the city was demanding and alive. At this time, Degas began to think of it in terms of its public spaces rather than of the

apartments and studios of his family and friends, as he had in the 1860s. One sphere that interested him in the 1870s, perhaps above all, was the Opéra. More than a theater where performances of operas and ballets took place, the Opéra was also an institution for teaching, training, and rehearsing. It was as well, to a great extent, a club for subscribers, who were even allowed backstage. In October 1873, its functions were disturbed when the old Opéra on the rue Le Pelletier burned down while the new one, designed by Charles Garnier, was still under construction (it opened in 1877). But there were alternative spaces, such as the Opéra comique and the Théâtre des italiens, so that the activities continued even if the architecture was not quite the same.

At the Opéra, Degas concentrated upon the ballets, which usually accompanied the operas but were considered subordinate to them. His first interest, already manifest in the late 1860s, was in the juxtaposition of the orchestra against the ballet being performed on stage. He moved on to depict dance classes and rehearsals on stage or in rehearsal rooms, which involved many figures in large and clearly defined spaces. One of these is *The Dance Class* (fig. 9), with the ballet master Jules Perrot, which was shown at the second Impressionist exhibition, in 1876. In that same exhibition, Degas included Chicago's painting *Yellow Dancers (In the Wings)* (pl. 10).

The Chicago painting seems, in many ways, a contradiction of *The Dance Class*. It is on stage instead of in a conventional room with a ceiling, moldings, and walls with a mirror. It shows parts of the bodies of three dancers as well as the legs of four or more, whereas the other work features at least (ignoring the reflections in the mirror) twenty-four figures—the ballerinas, their mothers or chaperones, and Perrot. In the Chicago canvas, which is slightly smaller in scale than *The Dance Class*, Degas decided to move closer to the figures and place them against the amorphous background of flats and stage. The three dancers in the foreground straighten their costumes and their hair, like several of the figures in the other painting. The central figure in *Yellow Dancers*, her gaze directed downward and to her right, could derive from the same source as the ballerina in the immediate foreground of *The Dance Class*. Furthermore, the cut of the dresses, the ribbons around the necks, the upswept hairstyles, and the flouncing skirts worn by the dancers are very much the same in both works. Although the dancer at the left in the Chicago work does not seem to have a counterpart in the other painting, the woman at the right, adjusting her corsage, is similar to the dancer near the mirror in the background of the rehearsal room.

From a closer vantage point, the dancers have, of course, increased in size and might have become monumental. But the artist did not focus on them as sharply as in *The Dance Class*, so the figures, although nearer, are less distinct. The light is also diffuse, without any suggestion of the control of spotlights. It falls rather haphazardly, gently caressing the beautiful arms and hands of the left dancer and shining a little more strongly on part of the bodice and skirt of the figure in the center. All of this is romantic and evocative, almost as if we were seeing the dancers and the stage through a theatrical scrim.

9. The Dance Class, 1874. Oil on canvas; 83 x 76 cm. The Metropolitan Museum of Art, New York, bequest of Mrs. Harry Payne Bingham, 1986.

These two works, which were probably painted about the same time, embody what Degas, in one of his letters from New Orleans to Tissot, described as the differences between the "English" and "French" representational traditions. The Dance Class, with its clarity, complexity of detail, and verisimilitude, conforms to the narrative tradition of illustration in English periodicals. In Yellow Dancers, through the simplification, enlargement, and obscuring of the subject, Degas not only contradicted the resulting "English" manner but accepted the resulting mysteries and anomalies, including the improbable spatial relationship between the row of dancers on the far side of the curtain and the foreground group preparing to go on stage. The element of wit in the glimpse of the dancers' legs under the curtain is more French than English. Much of the work depends on the sensitive handling of abstractions such as color, light, the rhythm of the brush strokes, and the situating of things in space and on the surface of the canvas; these are elements that Degas, at his most chauvinistic, might have claimed to be essentially "French" (and the English might not have denied it). In this sense, the Chicago canvas fits his description to Tissot of the second version of The Cotton Market (Fogg Art Museum, Harvard University Art Museums, Cambridge,

Mass.) as "less complicated and more spontaneous [than Portraits in an Office], better art."

It has been proposed that another composition of dancers in the Art Institute, the pastel over monotype Ballet at the Paris Opéra (pl. 11; detail p. 33), was included in the third Impressionist exhibition, held in 1877. This is highly probable, since we know that Degas showed several monotypes and pastels over monotype. In the exhibition catalogue, three untitled works are listed under Degas's name and are described as "drawings made with greasy ink and printed." This description of the technique of monotype does not convey the freedom with which Degas used it; often he completely coated the copper plate (he employed an unusually large plate for Ballet at the Paris Opéra) with greasy ink and then removed some of it with a rag, brush, or other instrument, and even his fingers. The casual mention that the drawings were "printed" does not indicate that it was almost impossible to pull more than two legible impressions—cognates—from each plate, or that impressions made after the first one were usually so pale that Degas could only use them as foundations for drawings in pastel.

Monotype appealed to Degas for many reasons. For dance compositions such as Ballet at the Paris Opéra, it provided a boldly conceived

compositional foundation that served to discourage the tendency toward minutiae which even his splendid *Dance Class* reveals. Working over the monotype with pastel made it possible for Degas to refine his draftsmanship, as well as to add the magic of color. A second impression (or cognate) of this print has never been found, and indeed it is suspected that Degas actually used the first (and perhaps only) print for the pastel. The blacks of the monotype are strongest where the foliage separates in the flats on the left. They are also indispensable for establishing the depth of the orchestra pit, a cavern from which the largely balding heads of spectators and musicians emerge, masculine and mundane. These figures represent reality, which monotype helps convey, whereas the dancers on the stage, delicately touched with pastel, move in the realm of fantasy.

The dancers appear immaterial, a sensation that their pale-pink tutus and the lighting enhance. The group of very young dancers at the right flutters hesitantly, the girls' dark hair cascading down their backs. The one closest to us seems to be arranging her companion's hair and possibly whispers in her ear. But their attention is fixed—as presumably ours should be—on the older and more muscular principal dancer, who stands uncertainly on her toes and forms her arms roughly into a "crown." Behind her—but very faint—are other dancers preparing to move forward into the spotlight. It is a charming scene in which imperfections enliven the fantasy, as do the small dots of red flowers Degas used to add sparkle to the pink tutus. Despite the prevalence of shadow, the structure in space is clear, as can be seen in the patch of pinkish light spilling over the floor and reflecting the shadows of the dancers. The sets are, in some respects, extensions of the dancers, with the tree trunks completing the movements of their bodies and their hair. Although the scenery is tropical and probably not something Degas had experienced firsthand, he revealed here surprising sensitivity to nature's moods, in the delicate trees and foliage rising evocatively from a lavender mist. Degas achieved a witty synthesis of the real and the make-believe, and of what he considered to be the English and the French styles of art.

Two of Degas's pastels over monotype of dance subjects, *The Star* (fig. 10) in the Musée d'Orsay, Paris, and the Art Institute's *On the Stage* (pl. 12; detail frontispiece), make a particularly interesting comparison, because the prints over which they were drawn were cognates. Over the first impression of the monotype, Orsay's, Degas used pastel to draw a shapeless but undoubtedly male figure in the wings, the antithesis of the

Although the scenery is tropical and probably not something Degas had experienced firsthand, he revealed here surprising sensitivity to nature's moods, in the delicate trees and foliage rising evocatively from a lavender mist.

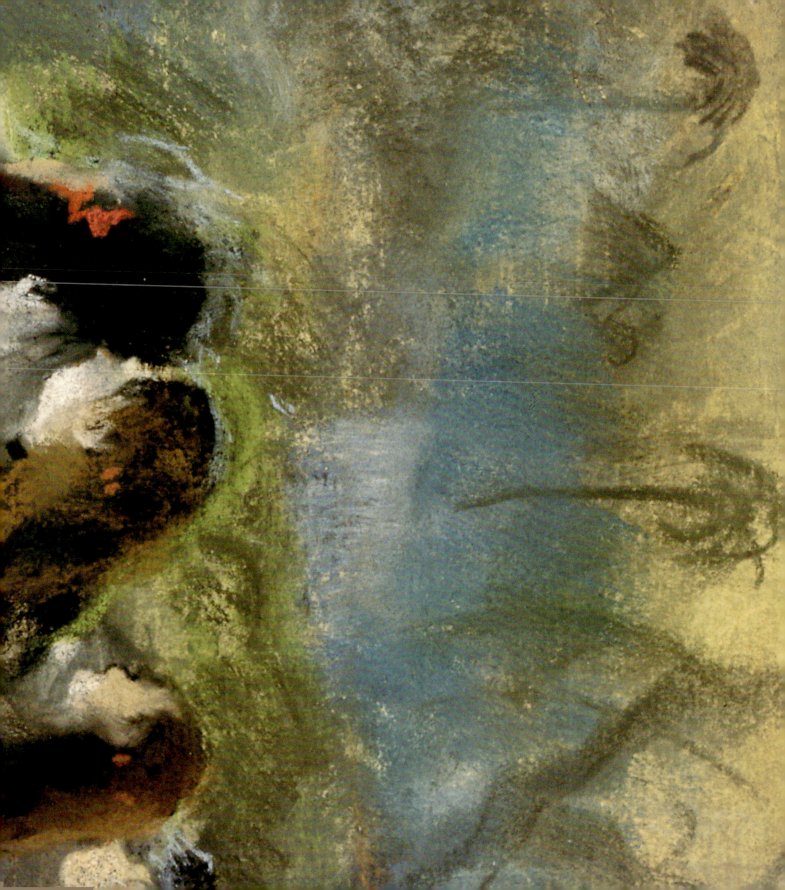

superbly on the pale-pink right leg, and the black ribbon around her neck corresponding to the movements of her body. We look down at her on the stage from a high point, perhaps a box in Garnier's opera house, but at an angle that reveals the dancers as well as the admirer behind the flats. The pastel is so restrained and delicate in color (pale oranges and blues on the flats, pale-pink touches on the dancer) that the strong monotype of this first impression, particularly in the floor, binds the work together.

When it came to executing Chicago's pastel, Degas did not imitate Orsay's *The Star*. The paler monotype is barely visible in the floor and in the flats. He did not leave the enchanting, solitary dancer intact but added three others, one with a leg provocatively stretched in front of her in the right-hand corner. In some ways, Chicago's principal dancer is less ethereal than her counterpart in *The Star*, something of a gypsy, but more harmoniously part of a charming ensemble. Her tutu is of a pretty aquamarine, also worn by the dancers surrounding her. In addition, she has a red bodice adorned by an ornament of red and gold with white dots like pearls. The ribbon around her neck does not float like the other dancer's; but her long, black hair flows captivatingly over her shoulders. There is no hint of a male figure in the background, but dancers, now four in number and clad in very pale pink, form a

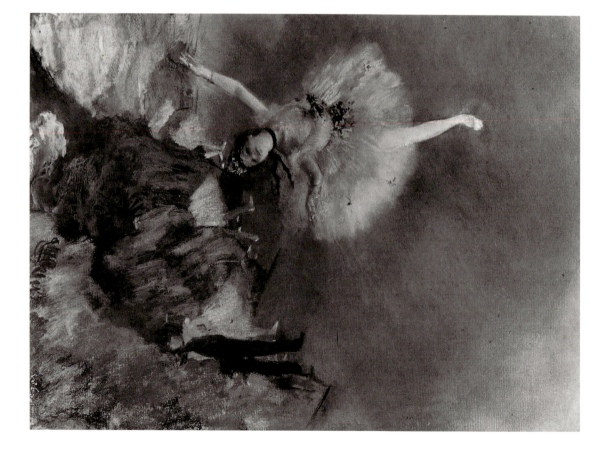

10. *The Star*, 1876–77. Pastel over monotype. 38 x 42 cm. Musée d'Orsay. Paris.

finely articulated female dancer who has just completed a soaring jump. Usually Degas liked to record the imperfections of his dancers rather than the supreme mastery shown here—the delicate arms held outward, the body balanced so

semicircle as they prepare to leave the stage. They are emphasized and brought closer to the principal dancer by a large passage of pinkish-white *essence* on the floor. In the upper right-hand corner is a spray of leaves, perhaps inspired by Chinese or Japanese art: flecks of white *essence* glimmer over the pastel's fixative. This work does not have quite the wit or élan of Orsay's *The Star*, but its gentle harmony is given spirit by the good-humored face of the dancer and the unexpected accent of the teasingly outstretched leg, belonging to a ballerina whose face we do not see. In the case of Orsay's *The Star* and especially Chicago's *On the Stage*, the monotype is a mystery, nearly invisible underneath the seductive pastel.

In a much smaller work, *Singers on the Stage* (pl. 13; detail p.106), the essential earthiness of monotype is more naturally fused with pastel. Here we are still within the world of the opera, even able to look from the stage into the theater itself, with its three great arcs of gilded boxes and the shadows of the men standing in their privileged positions on the floor. Degas used color as well as spatial composition to evoke the stage, setting off the whites of the chandeliers, gaslights, and mirrors; placing hints of rich color in the pale, golden pastel on the walls; and touching the costumes and furnishings with pink, red, and orange. The hair, elaborately adorned with flowers, of the singer in pink in the front is

echoed by the extraordinarily rich dress worn by the figure directly behind her. Although the performers are placed with a certain comic absurdity in relation to one another, the singer in orange in the background has a profile whose frailty and intensity are compelling.

In Paris the theater was close to an under-world of prostitution, a subject that Degas also explored at this time. For stage performers, as for laundresses and dancers, prostitution was an alternative profession. To depict this darker world, Degas rarely used any medium but mono-type. The small number of prints that could be produced meant that the distribution was limited. The range of light and shadows and the bold handling made monotype appropriate for subjects that were only discussed in whispers.

The Art Institute recently acquired one of the less sexually explicit of these monotypes, *Women on the Terrace of a Café in the Evening* (pl. 14). This unusually large plate focuses on the boulevards of Paris, where prostitutes gathered at cafés to rest, talk, or attract their customers. The rich, oily ink and the play of light and shadow provide a setting that is both glamorous and strange, somewhat evil, and evocative of the city itself. Degas wiped the plate clean in the foreground in order to be able to draw with a brush. His strokes are bold but supple in the description of the woven bodice and the untidy

We are not in a position to know how often Degas worked with pastel over a second monotype impression. Some monotypes, such as Chicago's small *Waiting* (pl. 15), are so unequivocal that it is difficult to imagine another version. In this work, a nude woman rises from her bed against a curtained wall, lit by a lamp at her right. By tradition, such ornaments as the locket on a ribbon around her neck and her bracelet would identify her as a prostitute. Even without these clues, however, her posture is so frank and without wiles, her black pubic hair so particularly prominent, that it would not be difficult to guess her profession. She is plebeian and far removed from the pampered courtesans of the time, like the *Olympia* painted by Degas's friend Manet (1863; Musée d'Orsay, Paris). Neither as slim, elegant, artificial, assured, or commanding as Manet's model, the nude in *Waiting* is petite and sturdy, her breasts small but firm, her face lively, and her hair absurdly bouffant. As she waits somewhat impatiently on the bed, half reclining, she is as real and earthy as some of Rembrandt's nudes. Her world is full of drama and mystery, expressed in the light and dark and in the two looming, phallic shadows in the background. Degas presented her, without justification or explanation, as a prostitute. Only a stroke scratched through her hair hints at a segment of the moon and suggests that she might be, for a

combination of hat, hair, and veil in the dynamic figure at the right. He was gentler and more solemn in his treatment of the central figure, with her round face and unruly curls spreading under her bonnet. The woman standing at the left is both more predatory and more puppetlike, her head reduced to two large, expressionless eyes and a tumble of hair. Almost hidden in the inverted triangle between them is another woman whose sharp, wise profile prevents any facile interpretation. This image is neither an apology for prostitution nor exactly a condemnation of it. Degas drew a segment of life that was only too easy to find on the streets of Paris.

In the 1877 Impressionist exhibition, Degas included another pastel over monotype with the same title, *Women on the Terrace of a Café in the Evening* (fig. 11). It is even larger than the Chicago work, and the monotype is so rich in the background that one suspects it was the first impression. Nevertheless, pastel softens and beautifies the image. In its greater precision, it is more animated than the Chicago work and provides more comic detail, with the result that the world it portrays is less ugly and vacuous— it is relieved by humor. Consequently, it was easier to exhibit and sell; indeed, the painter Gustave Caillebotte did buy it, lent it to the 1877 exhibition, and finally bequeathed it to the French nation in 1894.

second, ironically and improbably, a Diana, goddess of the moon and therefore of the night.

The antitheses of the sullen prostitutes found in the dark caverns of the brothels were the café-concert singers who performed in outdoor pavilions by the miracle of artificial light. Degas adored this form of entertainment and spoke and wrote about it with enthusiasm. His brother René claimed to be shocked by this when he visited Paris in 1872 (before persuading Degas to return with him to New Orleans). René wrote to his wife, Estelle: "After dinner I go with Edgar to the Champs-Elysées and from there to

the café-concert to hear the songs of idiots, such as the songs of a company of builders or some other such absurdity." In the opinion of the important, late-nineteenth-century American collector of Degas's work, Mrs. Horace Havemeyer, Degas represented "what the [café-concert] really is. The dazzling lights are there, the gay crowd is suggested, but you cannot fail to see the crass banality of the scene." The Art Institute has a lithograph (pl. 16) of one of the most popular entertainers, Mlle Emilie Bécat, whom Degas often painted and drew in pastel. In all three sections of the lithograph, Bécat is

11. *Women on the Terrace of a Café in the Evening*, 1877. Pastel over monotype on white wove paper; 41 x 60 cm. Musée d'Orsay, Paris.

shown in the darkest night but with light falling strongly on the stage and glowing romantically from glass globes of gas, like Japanese lanterns. Crowning the proscenium is a bower of leaves, which Degas handled as if he were one of the Japanese printmakers he and his American artist friend Mary Cassatt admired. Indeed, the print, with its abbreviated graphic vitality—particularly in the lower right, where Bécat assumes one of her characteristic gestures that were so frenetic they were described as "epileptic"—is very much inspired by Japanese art.

Although the technique of lithography, in which a drawing is made with a greasy crayon on stone, allows a very large number of impressions to be printed, there are only seven known impressions of *Mlle Bécat at the Ambassadeurs* (pl. 16). In all of them, the black of the crayon against white paper produces an effect of great brilliance. But the upper and the lower-left images are from known monotypes, transferred under pressure, when still wet, onto the stone. The scene at the lower right was probably achieved the same way, although the original monotype is now lost. Degas did touch up and sharpen the monotype images on the stone with lithographic crayon, tusche (the greasy, lithographic ink), and a scraper. In addition, he used a lithographic version (not the monotype) of the upper image, possibly later, as the basis for a

charming pastel, *Mlle Bécat* (The Pierpont Morgan Library, New York). In these images—in this case, more in the lithographs and the pastel than in the monotypes—there is an enchantment that helps us to understand Degas's enthusiasm for these outdoor nightclubs and Mrs. Havemeyer's defense of his concentration on them, even if they did not, as she put it, "represent perhaps the attractive place we Americans recall on the Champs-Elysées."

An arresting canvas in Chicago's collection, *Café Singer* (pl. 17), may be the only oil painting by Degas of a café-concert. It is related to two pastels and a drawing, the most finished of which (fig. 12) Degas showed at the fourth Impressionist exhibition, in 1879, prompting the press to caricature the singer's open mouth and upstretched, gloved hand. Degas's fascination with the gestures and physical effort of singers is revealed in a letter in which he urged a friend to "go at once to hear Thérésa at the Alcazar. . . . She opens her large mouth and there emerges the most roughly, the most delicately, the most spiritually tender voice imaginable." It appears that neither the oil nor the pastel portrays Thérésa (her real name was Emma Valadon). We still do not know the identity of the singer in the pastel, who, while plain, is full of energy, her physiognomy distorted by exertion and our vantage point. It seems possible that the woman who posed for Chicago's

painting was Alice Desgranges, a singer and the wife of pianist Théodore Ritter. Unlike the subject of the pastel, the woman in Chicago's work emerges from the shadows, her flesh made radiant by the warm light that falls on it. She is enchantingly beautiful; her mouth, although open, is exquisitely formed. It is as if Degas, delighted with his pastel, had decided on an alternative conception of the singer as elegant and gently bred, refinements he could evoke more easily in an oil painting.

Portrait after a Costume Ball (Portrait of Mme Dietz-Monnin) (pl. 18) was listed in the catalogue of the fourth Impressionist exhibition, held in 1879, but it and others also listed were never shown. That Degas was unable to deliver works that he had planned to exhibit may reveal the degree to which he was distracted by his financial debts at this time. But, unlike his portraits of Diego Martelli (1879; National Gallery of Scotland, Edinburgh) and Edmond Duranty (1879; The Burrell Collection, Glasgow Art Gallery and Museum), which he could not exhibit at the opening because he simply had not finished them, his reasons for not hanging *Portrait after a Costume Ball* may have been more complicated.

A draft of a letter from Degas to Mme Dietz-Monnin was discovered among his possessions after his death. Frequently published since, it

reads, in part: "Let us leave the portrait alone, I beg of you. I was so surprised to receive your letter suggesting that I reduce it to a boa and a hat that I shall not answer you.... Must I tell you that I regret having started something in my own manner only to find myself transforming it completely into yours?" Degas seems to have been persuaded to replace this with a more accommodating note, which has also survived. Both make it obvious that this portrait was that rare thing with Degas: a commissioned work.

It is also quite clear from other situations that, when he had to produce a work of art on command, he was invariably rendered creatively

12. *Café Singer*, 1878. Pastel on canvas; 51.4 x 40 cm (sight). Fogg Art Museum, Harvard University Art Museums, Cambridge, Mass., bequest of Maurice Wertheim, Class of 1906.

impotent. This response was further compli-
cated, in this case, by the fact that he also owed
money to Mme Dietz-Monnin's son-in-law, who
had probably arranged the commission as another
way of contributing to the artist's solvency.

It appears that the work was never finished.
But this does not mean that Degas had not
enjoyed that prospect. The Art Institute of
Chicago has owned for a number of years a pencil
drawing that, only in 1979, was identified as a
portrait of Mme Dietz-Monnin (pl. 19). The
sitter's bangs, raised eyebrows, and long,
upturned nose make the identification almost
certain. Degas must have drawn it casually when
he was working on the painting. He depicted her
in the upper left-hand corner of the page, so that
she would have a certain natural authority over
the space around her, even though she seems to
huddle within her collar or boa. Her expression
is reflective and somewhat sad, but mobile
enough to convince us of her transformation in
the painting.

The drawing that probably captures Mme
Dietz-Monnin's personality most vividly is a
pastel (fig. 13). As in the painting, she is dressed
in a somewhat absurd ensemble of ball gown, hat,
boa, and purse. She is neither young nor beau-
tiful, but her face glows; she smiles and waves
toward someone. We are further persuaded that
she was good-natured and gregarious by the very

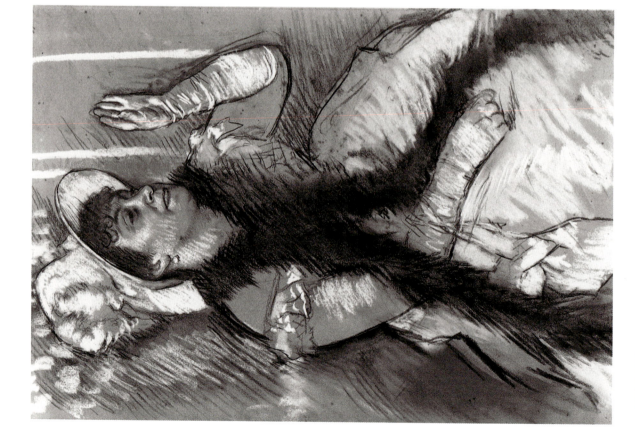

13. *Mme Dietz-Monnin*,
1879. Pastel on brown
paper; 47 x 31.8 cm.
Norton Simon Foundation,
Pasadena, California, gift
of Mr. Norton Simon, 1976.

directness and brevity of the strokes of charcoal and pastel. There is no doubt that Degas, in tackling the final portrait, fully hoped to be able to send it to the 1879 exhibition.

Essentially, while the Mme Dietz-Monnin of Chicago's painting is the sensible, friendly woman in the pastel study, her features are now more finely drawn, and the dark shadows under her eyes indicate a weariness, underscored by the whiteness of her skin. Although her costume is exuberant in style, it is surprisingly pale in color. Only the dark fringe of her hair and the offending and animated black boa provide a transition between the aging woman and the hopes suggested by her youthful dress. These contradictions make us sensitive to the cost of Mme Dietz-Monnin's exertions and her essential frailty.

As usual, Degas made good use of the space surrounding his sitter, in this case, a ballroom. He evidently considered the gilt-framed mirror important enough to have executed at least one drawing of the motif showing the reflection of her hat and shoulder, which he altered in the final work. The painting's mirroring of Mme Dietz-Monnin has a certain buoyancy, as if the atmosphere suggested by the artist could sustain her. In Degas's representation, she appears to be looking out at a world that is colorful and amorphous, embodied here in a gaudy bouquet of flowers. In front of the mirror and to the left

are the remains of the evening—dainty ballroom chairs—now empty and purposeless. At the far right is a curious, mysterious form, a dark shadow and what may be an oriental bust or vase, which would have remained an important focus.

Degas dashed with red paint. If the portrait had been completed, the raised, gloved arm and hand Its connection to the pastel *Café Singer* (fig. 12) is both compositional and chronological. Finished in 1879, the pastel was purchased by a friend of Mme Dietz-Monnin, who lent it to the Impressionist exhibition that year. But, more significantly, the gloved hand is important in emphasizing that, in the organization of this complex space, the focus is neither within the painting nor with us as spectators, but beyond and invisible to us, in the space to our right toward which that hand is gesturing.

Degas obviously wanted to make the final portrait particularly beautiful: pale and liquid, for the most part, but with soft splashes of color and accents of black. The materials he used—thin, chalky gouache and rich oil paint, charcoal as well as pastel, and metallic pigment—adorn the canvas. The inspiration, as it was for the lithograph of Mlle Bécat, must ultimately have been Japanese. *Portrait after a Costume Ball* may be unfinished, but in it we see a great work taking form.

Degas must have approached the 1880

The drawing . . . is very confidently executed, so sure of the suggestion of three dimensions through line that the sculptural effect does not have to be labored with extensive shading. Degas enjoyed leaving evidence of his execution—changes, repetitions, reinforcements—which is another form of bravura.

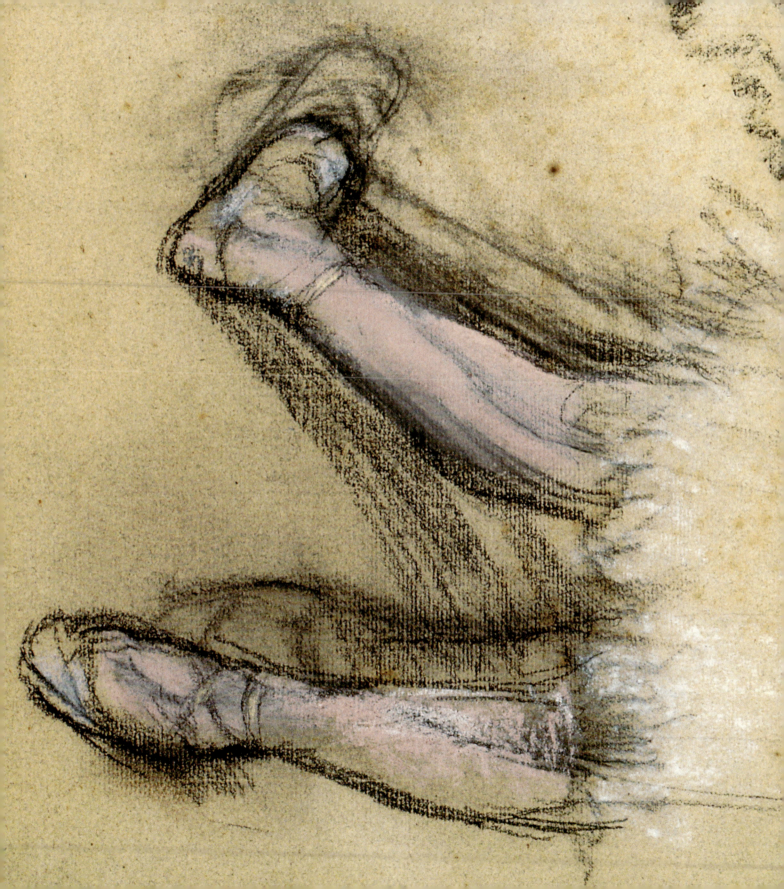

14. *The Fourteen-Year-Old Dancer*, 1879–81. Wax and other materials on a wooden base; h. 95.2 cm. Collection of Mr. and Mrs. Paul Mellon, Upperville, Virginia.

perhaps it was because, when faced with the opening of the exhibition, he decided he would like to make the changes to the boys and girls that have caused scholars to date the painting to 1880. The other work he promised, but did not send, was more critical to him at this time—the figure in wax and other materials that he called *The Fourteen-Year-Old Dancer* (fig. 14).

Degas had apparently been modeling in wax, clay, and plasticene for some years, but he had neither exhibited these works nor dated them. *The Fourteen-Year-Old Dancer*, the largest sculpture he was ever to attempt, is also one of the few that can be related to a specific date—1880, when he wished to exhibit it. For a number of reasons, the glass case intended for it remained empty during the exhibition. One of Degas's difficulties with the work may have been that it involved the collaboration of so many craftsmen: the seamstress who made the gauze tutu and the white piqué bodice with real buttonholes, the cobbler who provided the shoes, and the wig-maker who produced the hair. Degas promised it again for the next Impressionist exhibition. This statue—undoubtedly his greatest achievement as a sculptor—was not ready for the opening, but it was put in place to universal astonishment before the 1881 exhibition was over.

Degas must have made models in clay and wax, as well as many sketches on paper, for this

Impressionist exhibition, the group's fifth, with something of the same trepidation with which he had approached the fourth. This time he promised the London version of *Young Spartans* (fig. 5). We do not know why he did not show it—

figure. The only piece of sculpture connected to it that has survived is of the body, nude and somewhat smaller than the dressed figure, but it is now argued convincingly by some that it was modeled later. Only eight sheets of drawings directly related to the sculpture have survived. Chicago's *Three Studies of a Dancer in Fourth Position* (pl. 20; detail p. 43) is the only one showing her dressed, as she is in the final work, and from three points of view, as if the artist were studying the figure in the round. The drawing, in charcoal with some pastel, is very confidently executed, so sure of the suggestion of three dimensions through line that the sculptural effect does not have to be labored with extensive shading. Degas enjoyed leaving evidence of his execution—changes, repetitions, reinforcements —which is another form of bravura. A curious aspect of this sheet is that, whether it is a study *for* or *after* the sculpture, each of the three figures has a separate identity, detected first in the differences in their hair. The dancer in the center is older, taller, and thinner than the others; she holds her position as if it were a rather boring routine. The smaller dancer at the left is younger and apparently somewhat strained in the shoulders from maintaining the fourth position. She is Marie van Goethem, who posed for the sculpture and whose simian features were reviled by critics. Finally, the dancer at the right is younger still,

with an urchin's charming face and tumbled hair tied by a buoyant ribbon. It would be amusing to know how Degas actually conceived this drawing. There is a pride in the postures of the three dancers, which reflects the statue, of course, but could also reflect a celebration of its completion. Like the urchins from Montmartre in Degas's 1880 version of *Young Spartans*, these young dancers are endearing in their homeliness, courage, self-discipline, and will. Essentially, if only at this moment in their lives, they are images of hope rather than despair.

Dancers as a subject continued to interest Degas throughout his career; but later they were to become symbols rather than individuals. In the 1880s, however, they still posed in his studio. He knew their names and was, at times at least, concerned with their welfare. It is therefore natural to be curious about the identity of the dancer with the long, black hair in the Art Institute's pastel *The Star* (pl. 21; detail p. 49). Possibly, as has often been suggested, she is Rosita Mauri, who made her debut at the Paris Opéra in 1878. Whomever she may be, she is certainly the star upon the stage. We look across that stage along its boards to the boxes behind her to the left, conscious, in spite of this rapid recession, of the bevy of dancers to the right. Clad in light-blue tutus and the usual pale-pink stockings, the corps strikes many poses and

moves in many directions, in apparent disorder as well as with animation. The star stands in the third position, looking upward at the balconies and responding to what we assume is applause by blowing a kiss to her audience.

For two reasons, we know this work dates from about 1880. One is the simple classicism of the prima ballerina: she is much larger than the corps de ballet, supporting and balancing their seemingly uncoordinated movements like a column. Despite their evident disarray, the dancers appear miraculously to have left a space between themselves and the principal dancer. She is literally surrounded by a halolike expanse of floor. The red box directly behind her and the perspectival recession of the boards of the floor stabilize her further. Every artifice is used, including the rose color of her shoes, her ornamented bodice, and the flowers in her hair, to emphasize her importance. Gone now is the pretense of the natural, probable, and informal, let alone of the wit, that characterizes Degas's art of the 1870s. There are technical changes as well. Degas did not work the pastel over a monotype, or any other form of print, but drew it directly on a piece of wove paper, leaving clear evidence of the rhythms of his long strokes. These model the forms exquisitely, as can be seen in the star's neck and collarbone. They make the tutus buoyant and suggest the monotony of the floor.

But their role is also structural in establishing an overall order.

After the achievement of *The Fourteen-Year-Old Dancer*, Degas sought further opportunities to develop the sculptural, even in two-dimensional works. He did this in individual drawings such as *Dancer Bending Forward* (pl. 22), choosing a blue paper on which he could work into the shadows with black charcoal and into the lights with strokes of pastel. As he had in the drawing *Three Studies of a Dancer in Fourth Position* (pl. 20), he left evidence of his reworking, changes of emphasis, and doodling, but now these are even cruder. The contours of the limbs are uniformly heavy and monotonous, the hatching on the legs is perfunctory, and the outline of the dancer's left foot is brutally distorted. Yet the overall effect of the drawing is strong and dramatic. Because her head is bowed, we have no sense of this dancer's individuality, but her mute emotions are powerfully conveyed by her stance, her strong arms and shoulders, and the light—white pastel on her arms and gold on her hair—that falls from above. Any movement made by this figure would be the result of force driving mass, rather than of articulation. She represents what Degas was seeking to express about the human body in the 1880s, and she is part of the consuming interest in individual drawings that distinguished Degas from his contemporaries.

To move from the image of that powerful dancer to *Mary Cassatt in the Painting Gallery of the Louvre* (pl. 23a) is something of a shock. We have moved back a year or so in time, to the very end of the 1870s. We have also, however, shifted from a neutral space, which must have been some utilitarian rehearsal room, to that of the painting galleries in the Musée du Louvre, complete with a handsome parquetry floor, marble doorjamb, and masterpieces hanging on the walls. This change of location is not enough to explain the differences, but the identity of the figures can. The distinguished woman, whom we see from the back, leaning restlessly on an umbrella, is the American painter Mary Cassatt, a great friend, if not lover, of Degas; the seated woman is usually identified as her sister. The posture of Miss Cassatt, as she was usually known, conveys an assurance that comes not only from self-reliance but also from custom, breeding, and manners. She seems here to withdraw somewhat from the paintings before her, which she is probably regarding not only with interest but as a challenge. Her silhouette in the monochromatic etching is the ideal illustration of a point made by Degas's friend Edmond Duranty, who wrote in his 1876 essay "The New Painting" (to which it is assumed Degas contributed ideas): "With a back, we can discover a temperament, an age, a social position." Cassatt was independent and impa-

tient, about thirty-five, and the sister of the president of the Pennsylvania Railroad.

The print in the Art Institute may be the only recorded impression of the sixteenth state of some twenty Degas made of this image. Since he and Cassatt shared an enthusiasm for print-making and for Japanese prints, it is appropriate that he chose to use the vertical proportions of a Japanese pillar print. A technical masterpiece, it has been described as "one of the most complex prints in its combination of media," in which "it is difficult to separate precisely the work in etching, soft-ground etching, drypoint, and aquatint." These were refinements Cassatt would have appreciated and understood. She would also have respected the search for perfection that led Degas to push the image through so many states, during the course of which her hat—she did upon occasion go to the finest milliners and dress-makers—took four different forms. Ambitious in both the technical and aesthetic senses, the resulting print is a brilliant achievement.

Although Degas made the first state of this print in about 1879, we know that he was still working on it in the 1880s, because he took a state of the print that was an intermediary between the twelfth and thirteenth states, coated it with pastel, and inscribed it "Degas/85" (pl. 23b; detail p. 71). It was not unusual for Degas in the mid-1880s to color his prints,

Clad in light-blue tutus and the usual pale-pink stockings, the corps strikes many poses and moves in many directions, in apparent disorder as well as with animation.

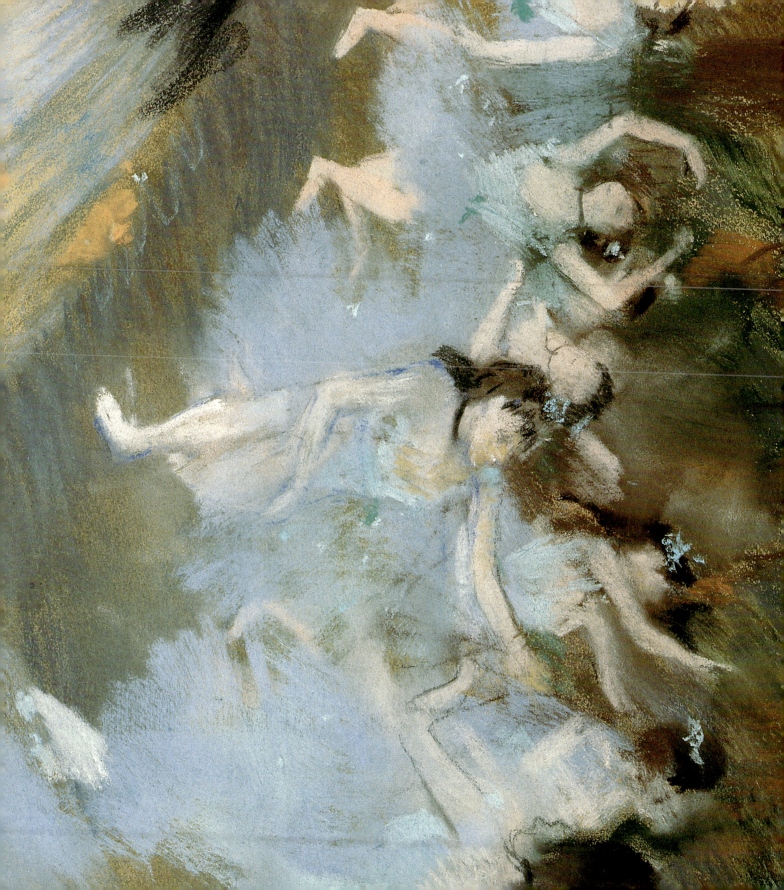

perhaps hoping to increase their marketability. In fact, the hand-colored version of *Mary Cassatt in the Painting Gallery of the Louvre* did find a buyer —Ivan Shchukin, one of the early Russian collectors of late-nineteenth- and early-twentieth-century French art.

Cassatt not only bought chic hats from fashionable milliners, but she occasionally took Degas with her, as did Mme Straus, the widow of the composer of *Carmen*, Georges Bizet. When Degas decided to use visits to millinery shops as a subject, Cassatt occasionally posed for him. Her friend Mrs. Havemeyer asked her if she did this often. "'Oh, no,' she answered carelessly, 'only once in a while when he finds the movement difficult, and the model cannot seem to get his idea.'" Mrs. Havemeyer did comment on one pastel for which Cassatt was the model, *At the Milliner's* (1882; The Metropolitan Museum of Art, New York): "The movement of the hand that places the hat upon the head, and her pose as she leans upon an umbrella is very characteristic of her." But it was a prettier model than Cassatt who posed for Degas's greatest painting of this subject, *The Millinery Shop* (pl. 24; detail p. 53).

Degas made some exquisite pastels of milliners in the early 1880s, but none are as large and as generous as this painting. We look down at the hats, the table, and the milliner as if we are standing close to them. The hats themselves, four of them balancing on decorative stands, one lying on the table, and another held in the milliner's hands, are like flowers in full bloom, lavish but fragile. Two rather utilitarian hats are subordinated in the shadows. The milliner wears a simple gray dress as she, with a pin in her mouth, contemplates some adjustment to the hat she holds. Although the most intense colors are provided by the yellow-green baize ribbon and the brilliant blue bow of the two hats in the center of the canvas, the pale yellow hat at the left is rendered so enchantingly luminous by a passage of daylight from an unknown source that it buoys up our spirit much as a blossom would, and is quite capable of competing with the charms of the unassuming young milliner. Even if we are made to feel somewhat removed, *The Millinery Shop* is a painting that gives great pleasure very simply, by reflecting the artist's own when he visited such establishments with Cassatt or Mme Straus.

A pastel that also delights our eyes immediately is *Harlequin* (pl. 25), which is dated 1885. A background of the most vibrant green is shattered in the upper left by a group of dancers with vacuous black eyes, while a female dancer wearing the brilliant suit of the commedia dell'arte character Harlequin Senior dramatically

inspects a gray bundle on the stage. Degas's Italian experience must have influenced his interest in such subjects, particularly when they made their way into operas and ballets in Paris at that time. *Harlequin* depicts a scene from *The Twins from Bergamo*. We know Degas witnessed a production of the work at the casino in Paramé (St.-Malo) in August 1885, in which three dancers who often posed for him assumed the principal roles of Harlequin Senior, Harlequin Junior, and Colombine.

The beauty of the work comes largely from the handling of pastel. Crisp, hatched strokes form the diamonds on Harlequin's costume in iridescent blue, red, green, and a more subdued yellow ocher, spilling over the black outlines that divide these patches of color and that make them seem to vibrate. At strategic points in this suit, where the black lines meet, Degas added at the last, over the fixative, lively white spots of gouache. In the socks, the white is particularly luminous. The green foliage, on the other hand, is very freely handled, as his artificial landscapes tend to be, but this is further—and unusually—animated by the staring eyes of the dancers in the wings at the upper left. Against this lively background, the inert gray bundle, which appears to be a body wrapped in a blanket, arouses the curiosity and bewilderment of Harlequin Senior.

Its opening will inevitably be a surprise: it will reveal his brother, Harlequin Junior, who has disguised himself to flirt unwittingly with the girl Harlequin Senior also desires.

By the eighth (and last) Impressionist exhibition, in 1886, Degas's work was becoming increasingly stable. This is apparent in the female nudes he proudly showed then. But earlier in the 1880s, the direction toward this classicism was not always clear. Something of what may have been his own ambiguity is shown in a pastel in the Art Institute's collection, *Retiring* (pl. 26). The artist used pastel here to create a mood that departs from the wit of the scenes of the 1870s. The world of the woman in *Retiring*, in which the arrangement of the curtains plays an important role, seems domestic and protected. She is tall, her proportions conventional, and her modest breasts agreeably rounded. Degas drew the rest of her body so severely that it seems angular and almost undernourished. She sits in a natural position that conceals her public hair, and, as she leans to adjust the lamp, she seems more an ordinary woman than a temptress.

Degas seems to have relished her domestication. The sheets are a brilliant white heightened with blue. The lamp, with a pretty, white shade, is of a handsome oxblood pottery or porcelain. Cards or notes are arranged around it on the

The hats . . . are like flowers in full bloom, lavish but fragile.

dainty table. But it is the curtain, with its rich application of greens and orange, that is particularly magnificent. The nude may be a prostitute, but she is living in bourgeois comfort. Only her frailty could arouse our concern.

A monotype from the 1880s in Chicago's collection, *Female Nude Reclining on Her Bed* (pl. 27), is more shocking. Although it may also be described as a nude by a lamp, that would hardly convey the impact of this coffin-shaped image. Degas left most of the rich, black ink on the copper plate and created a dramatic effect of chiaroscuro, some of which he removed to expose brilliant white paper for the lamp and the paper on which she rests her right hand. The figure itself is so dark that the image has been compared with a 1658 etching by Rembrandt, *Negress Lying Down*. Degas's reclining woman is muscular and powerfully formed, more so even than the figure in *Dancer Bending Forward* (pl. 22). Her parted legs are almost Michelangelesque. Because of the depth of the darkness, much remains obscure, which means that the few places touched by light—like the soles of her feet or the bracelet on her right arm—are tantalizing. It is a tumultuous rendering of desire so consuming that the head is reduced to strands of hair. In this heroic monotype, the artist's touch is profoundly physical and sexual. Works such as this one may have been outlets for the eroticism

that is absent from the remarkably sedate nudes Degas produced after the mid-1880s.

On 13 June 1889, Degas wrote to a very good and enduring friend, the sculptor Albert Bartholomé: "I have worked the little wax a great deal. I made a base for it with rags soaked in a more or less well-mixed plaster." It is now believed that he was referring in this letter to the delightful statue known as *The Tub* (see pl. 28). Until Paul Mellon bought the original waxes in 1956 and subsequently donated many of them to museums (in particular to the National Gallery of Art, Washington, D.C.), Degas's work as a sculptor was largely known from bronze casts, like Chicago's, made after his death. The artist, of course, never saw the sculptures in metal. Although it has always been known that Degas improvised with materials and would add pieces of paper to his drawings and pastels and experiment with a combination of media in his two-dimensional work, it was still shocking to discover the degree of his technical improvisation in the original "waxes." Fortunately, Degas did not use a real lead basin in *The Tub*, so the National Gallery's conservators were able to x-ray it from below. They discovered its ingredients to include colored beeswax, plaster, cloth, cork, wood, wire, and a lead-alloy strip.

Like the *Fourteen-Year-Old Dancer*, the bather (either in the wax or, as here, in bronze), is

another of Degas's charming adolescent figures, although she seems almost younger, primarily because *The Tub* is much smaller, measuring only some twenty inches across. Thematically, she is a natural descendant, as she examines her toes in the tub, of the pastel drawings of bathers Degas had shown only three years before at the last Impressionist exhibition, which he described as a "suite of female nudes bathing themselves, washing themselves, drying themselves, wiping their faces and hands, combing their hair or having it combed." Degas gave the bather the piquant features of the model and a playful air.

In the 1890s, Degas continued to concentrate upon the nude, writing to an artist friend on 6 July 1890: "I am hoping to do a suite of lithographs, a first series of nude women at their toilet." The Art Institute owns the fourth state of the first of these (fig. 15). In this image, we see a young woman, almost still a girl, from the back; she leans to her left and lets her long hair flow down as she dries her left hip with a towel. The roughly indicated, domestic interior, with patterned and crumpled curtains, a tufted chaise where a rat of hair curls up like some animal, provides a domestic foil for the smooth, youthful body. Degas emphasized the figure's supple beauty through the flowing, albeit interrupted, contour lines, drawn directly on the lithographic stone. There is no implication, in this image, of

sexual experience or inexperience. It is charming and pure.

Degas built on this series of lithographic nudes by varying them drastically and introducing the figure of a maidservant. *After the Bath (large plate)* (pl. 29) is the final image in the series, and hints at the radical transformations that would take place in Degas's last works. He used a square stone for these later lithographs, in which he depicted the bather only from her hips upward. He reversed the position so that the

15. *Standing Woman Drying Herself*, 1890/91. Lithograph on ivory wove paper, fourth state of six; 33.3 x 24.6 cm (image), 42.2 x 30 cm (sheet). The Art Institute of Chicago, Clarence Buckingham Collection, 1962.81.

bather's hair—very much shorter—falls downward at the right. The form of her body is suggested by gradations of shadow or the absence of shadow rather than by contour lines. As a result, although she is solid, which the emphatic groove of her spine makes clear, she does not provide the same invitation to caress as her predecessor. The background, now neutral, does not distinguish itself from the figure; in fact, background and body seem to merge at points into an abstraction. Most surprisingly, the maid, whose attentive features appear in earlier states of this print, is now reduced to two hands, which hold a towel over the bather's head like a benediction. We seem to have moved from gentle enjoyment of a freshly washed female nude into something more metaphysical.

In 1896 Bertha Honoré Palmer, wife of Chicago hotel owner Potter Palmer, courageously bought the pastel *The Morning Bath* (pl. 30; detail p.59) from Degas's dealer, Durand-Ruel. Although in this work the nude steps energetically and naturally into the tub, her pose actually derives from copies after the Old Masters that Degas executed in his youth. It was probably in the print room of the Bibliothèque nationale that he made drawings after an engraving by Marcantonio Raimondi after Michelangelo's lost fresco, *The Battle of Cascina*, which provided him with a

precedent for the thrust of the torso, if not for the contour of her left hip.

Degas was able to give even more force to the diagonal posture of the figure in the pastel through the angles of the bed, the tub, and the walls. Her energy is also reinforced by the perspective Degas used: despite her small size, she is at the center of a dramatically foreshortened space. We seem to move in *The Morning Bath* along with the dynamic nude, from the comfort of the white bed, in which the pastel was laid on with a brush, to the sumptuous alcove in which she cleanses her body. In some ways, she becomes a reflection of the colorful room, although she was drawn first in charcoal. Along her breast and stomach are touches of the blue of the curtain, and her pink skin is dappled with spots of the greens of the wall. Her mop of black hair picks up the shadows in the curtain and beside the tub. There are other harmonies, such as the lilac in the towel repeated in the sheets of the bed. Because the pastel was applied in many layers, with many different kinds of strokes so that the various layers show through, the fabrics, particularly the blue curtain, are extraordinarily rich in hue and texture. Cool as the colors appear, the layer underneath them is orange, which is now only visible in a few spots. *The Morning Bath* is a quiet but indulgent visual feast.

Unlike the *The Morning Bath*, where the pastel is opaque, the colors appear rain-washed, and the concentrated physical energy of the bather seems to thrust away from the surface of the picture plane, *Two Dancers* (pl. 31) is thinner and more muted, and its figures move tentatively toward us from the flats on the stage. This work, from the years between 1890 and 1898 began, like *The Morning Bath*, as a charcoal drawing, but now the smudges, as well as clean strokes of charcoal, persist through and around the pastel. Green and deep-blue pastels are worked into its blacks against a yellowing tracing paper to create a grotto in the background and a stage set tree, at the right, whose surface resembles art nouveau glass.

In the many studies of dancers in charcoal Degas made for this work, the tall, angular figure wearing a long tutu is always dominant. This auburn-headed principal dancer is so determined in pose, and the nose of her aging face is so fierce, that her authority cannot be diminished by the vision of the prettiness of her bouffant dress and the stage. The dancers emerge gradually from the illusion of the grotto, first through the magic color of their tutus and bodices, with the oranges glowing particularly radiantly against the violet pink. Finally, however, it is the light falling from above on the first ballerina that reduces her face to a mask, reveals the vitality of her arms, and strikes her shoulders and throat, defining them so superbly that their suggestion and expression of strength, in that fragile and illusory world, seem the purpose of the pastel.

Periods are always arbitrary in any artist's work. With Degas it is convenient to use decades, since he returned from Italy to Paris in 1859, the Franco-Prussian War broke out in 1870, the Impressionist exhibitions of 1879 and 1880 could justify the identification of a change, and even the importance of 1890 can be explained in terms of his evolving attitudes toward his favorite subjects. On the other hand, one could argue that Degas's first acceptance to the Salon of 1865 was a more crucial event than his return from Italy; that 1873 and 1874, which witnessed his return from New Orleans and the first Impressionist exhibition, were critical years; and that 1886, the date of the last Impressionist exhibition, represented the beginning of a decade of significant change. Certainly, between 1886 and 1896, much happened to Degas, including the deaths of family members and friends, and, by 1892, the reconciliation with his brother René and his second family; Degas had also found a three-story apartment with which he was content—it had one floor for his domestic

Because the pastel was applied in so many layers, with many different kinds of strokes so that the various layers show through, the fabrics . . . are extraordinarily rich in hue and texture. . . . "The Morning Bath" is a quiet but indulgent visual feast.

needs, one for his studio, and the third for the art collection he had begun to acquire; and he was admirably attended by a former schoolteacher named Zoé Closier. His passion for photography grew; and, early in the 1890s, he made some remarkable photographs of himself, and a few with Zoé. Durand-Ruel continued to be his dealer, and eventually Ambroise Vollard handled his more unconventional works. In 1892 Degas had his first one-man exhibition, at Durand-Ruel's, in which he showed landscapes in monotype, many covered or partly covered in pastel. These romantic and evocative works are related to the landscapes he painted as the background flats for his dancers. During this period, he indulged his lifelong love of music. A great admirer of the opera singer Rose Caron, he followed her performances, even when it meant listening to the music of Richard Wagner, which he disliked. Degas's works were becoming more abstract and poetic, but the figures in them—whether the nude of *The Morning Bath* or the principal ballerina of *Two Dancers*, for example —still retain a strong sense of the purpose of life and of their roles in it. Neither Degas nor the figures in his works are guilty of despair.

We can identify which works date before 1896, because fortunately a friend of the artist published a group of reproductions of some of his drawings in that year. This date is significant, because, around that time, we can detect a decided change in mood in Degas's art. Perhaps encouraged by his more conservative friends and probably by René, who was an editor of a very reactionary, anti-Semitic newspaper, the artist supported the anti-Dreyfusards when the Dreyfus Affair—the case of a Jewish military officer who was falsely accused of treason and harshly sentenced—divided France between 1894 and 1906. Whatever his reasons may have been, this position cut Degas off from friends, which did not make him happier. His one consolation was in now being able to afford to collect works of art. He bought works by contemporaries such as Paul Cézanne and Paul Gauguin, and paintings and drawings by his great predecessors such as Eugène Delacroix and J. A. D. Ingres. Dreyfus was eventually freed and pardoned; and Degas did achieve a reconciliation of sorts with some of his Jewish friends. But his eyesight, which had always been poor, deteriorated so severely that he had to give up painting by about 1908, and eventually sculpture. For the final ten years of his life, he was both a legend and a lonely old man whose greatest pleasure was walking through the streets of Paris (see fig. 18).

The last decade in which Degas worked seriously was probably between 1896 and 1907, the year the critic and collector Etienne Moreau-Nélaton wrote about a visit to the artist's studio.

In these years, he was executing most of his pastels and drawings on tracing paper, either because he relished the fact that it was probably ephemeral, or because he could more easily copy from one drawing to begin another with considerable alterations. He was using the same subject matter as in the past—dancers and nudes—working out changes on earlier themes and compositions.

The late nudes, such as Chicago's charcoal drawing on tracing paper, *After the Bath (Woman Drying Her Feet)* (pl. 32), do not suggest any elements of particular individuality. As this nude sits on the edge of a tin bathtub, which Degas kept for years in his untidy studio, she appears heavy and strong, the mass of her muscular body emphasized by solid black lines and some brief hatching. Since the balance of that body on the edge of the tub is not quite convincing, the fluid, grayed strokes of the towel are needed to sustain it. Although the figure has a sculptural power, which the marks of charcoal—some no more than zigzag doodles—reinforce, it is not articulated rationally. The movement of the left arm, which picks up a piece of fragile fabric, seemingly dissolving in the air, is exaggerated and meaningless. The bather's awkwardly contoured and smudged hair, which appears to spring rather than flow downward, fades out somewhat gracelessly against the paper like spent smoke. The hair recalls that of the bathers in the lithographs of the early 1890s, but it has neither the luxuriance of what we see in *Standing Woman Drying Herself* (fig. 15) nor even the vibrancy of that of the nude in *After the Bath (large plate)* (pl. 29). However, the energy of the artist's incidental strokes—for example, in the squiggles in the bathtub or the tangle of black charcoal falling from her left hand onto the floor—invigorates the image. What the figure does express is a struggle between will-power and inertia, with inertia not yet victorious. Although intelligence and human sensitivities are ignored, a classical balance is nevertheless heroically achieved.

It is very difficult to date these late drawings of Degas—and he made many in charcoal of a nude sitting on the edge of a bathtub drying her shins. They vary with considerable subtlety in proportion, composition, and handling. One, most exceptionally, is dated 1903 (fig. 16). More diffuse than the Chicago drawing, the charcoal is also lighter; a few touches of pastel were added, and there is some indication of a room. While the body of the nude is more energetic and blowzier, on the whole the sheet expresses a greater sense of futility because it is less controlled and less resolved than *After the Bath (Woman Drying Her Feet)*, which, one suspects, must come from the more disciplined years of the late 1890s.

There were rare occasions—perhaps more

The Bathers (pl. 33), which has been dated, without much conviction, to sometime between 1895 and 1905. Degas drew sparsely on a piece of tracing paper over forty inches wide, possibly beginning with the two bathers in the lower-left two-thirds of the sheet, and unifying the composition with a vast landscape that is like the segment of an enormous hemisphere, reminiscent in its abstraction and romanticism of the small landscapes shown in Degas's only one-man exhibition, held in 1892. This vision of the earth is as empty as a tundra, the sky promising rain if not storms, the clouds on the horizon indistinguishable from distant mountains, the water an unlikely and murky turquoise, the grass a more probable jade. Out of the lagoon, toward the horizon, the smallest of the nudes rises as if she were an island. Although this figure has been compared with some of Degas's earlier bathers, her physique is unfamiliar: her hips are small, her breasts heavy, and her broad, heaving shoulders are emphasized by shadows that break across the sky. With her arms plunged into the dark, opaque water, she appears to be searching in perpetuity for something unknown. Her head, defined by an almost translucent mop of red-golden hair hardly attached to her body, reflects her despair at the futility of her action.

Although the figure on the horizon is a new creation, the other bathers have meaningful

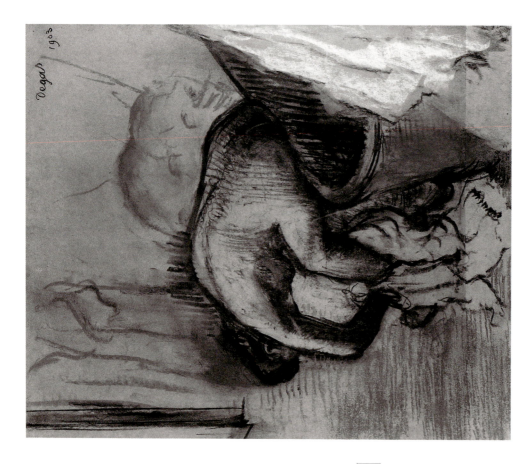

16. *Woman at Her Toilette.* 1903. Charcoal and pastel; 58 x 54 cm. Museu de Arte de São Paulo, Assis Chateaubriand.

frequent in his late years—when Degas made an effort to stand back from his subject, certainly to contemplate its more universal meaning, exceptionally to forget that he normally composed with a revealing fragment, and usually to recall some of the works he (or others) had produced in the past. This seems to have been the case with Chicago's large drawing in charcoal and pastel,

antecedents. The two nudes at the left were probably traced from those in Degas's thickly encrusted pastel *Two Bathers* (c. 1886–90; private collection), who are sensual and corporeal. In Chicago's composition, Degas apparently sought to isolate the figures, making the crouching bather on the left smaller and pulling her further away from the reclining nude. While, in the earlier pastel, she simply and somewhat hedonistically enjoys wetting her feet, here she appears to be hunting for something in the dense water with her tentatively outstretched right hand. Fundamentally, she is not too unlike Degas's series of bathers seated on the edge of a tub, such as the previously discussed charcoal drawing *After the Bath (Woman Drying Her Feet)* (pl. 32). There could have been times, however, when Degas may have contrasted this crouching, hesitant, vulnerable figure to Ingres's proud *Valpinçon Bather* (1808; Musée du Louvre, Paris), with her smooth, continuous, perfect flesh. Degas also identified himself with his contemporaries, and he would not have been displeased with the comparison of this nude with those found in the paintings—both early and late—of Cézanne, which Degas admired and collected. And although Degas might not yet have known the artist Henri Matisse (who was to buy at least two of Degas's paintings), after drawing *The Bathers* he should have been ready to relish

Matisse's *Bathers with Turtle* (c. 1908; St. Louis Art Museum). Degas's crouching figure thus serves to link the past and the future.

The ungainly, restless bather in the center of the composition may have had even more associations for Degas, although largely related to his own works. The figure could have reminded him, as it has others since, of some of the exquisite studies that he drew for the ravaged figures in *Scene of War in the Middle Ages*, exhibited at the Salon of 1865. On the other hand, it may have suggested the twisted figure of Venus looking up at a small, winged Cupid in a tiny painting by Cézanne from the 1870s, *Venus and Love* (private collection), which Degas had bought in 1897. But it most closely resembles the figure of a nude reclining on the floor with her arm raised to hide her eyes, found (in reverse) in two of his own pastels, the first (Musée d'Orsay, Paris) probably made shortly after the 1886 Impressionist exhibition, the second (private collection) about a decade later. The bodies in these pastels are slender, graceful, and sensual. In Chicago's *Bathers*, the center nude, unlike its probable sources, is cumbersome and impossible to seduce or satisfy.

Finally, there is an ambiguous figure in the lower-right-hand corner. Usually identified as female, it has more than once been suggested that Degas based it on drawings he made in his

youth of the warrior pulling on his leggings in Raimondi's engraving after Michelangelo's lost *Battle of Cascina*. The arc of the figure's back, which effectively closes the composition in that corner, is similar to that of Michelangelo's soldier; and, although Degas's figure is by no means as husky as the great Renaissance artist's Roman warrior, the limbs do have an angularity that, together with the helmetlike shape of the hair, could suggest a male youth. Nevertheless, the curve of a breast is revealed under the arm. It is not impossible that the figure is a hermaphrodite, and that there could be allusions which Degas's classical education might explain.

The Bathers, so interesting as a seminal work for Degas's career, is essentially a composition without hope. Even the landscape, although not necessarily barren, does not offer comfort. Each figure is separate, involved in self-generated activities of almost absolute futility, not providing companionship to one another, except perhaps through proximity. The most decisive action is performed by the figure pulling on one loosely woven, wool stocking of a brilliant blue, while the other lies across the leg closest to us. *The Bathers* seems a denial of most of Degas's mature work, which, while never saccharine, dealt with hope and the expectation of fulfilling it through discipline. It also stands apart from the idyllic, nurturing paradise Degas had acquired for

himself when he bought Gauguin's *Day of the Gods* (1894; since 1926 in the Art Institute), and from the sublimity of Cézanne's *Large Bathers* (1906; Philadelphia Museum of Art), which Degas could have seen in Vollard's galleries or in the Cézanne memorial exhibition held in 1907.

The Bathers is a large drawing, not an unfinished pastel; its physical construction helps us understand Degas's conception of the work. As the artist neared completion of this spare and highly cerebral composition, he decided it needed more air. He added broad strips of paper along the bottom and top, but worked upon the lower in a perfunctory fashion, never harmonizing it with the original section. After spraying with a fixative, he drew, with a certain relish, the intensely blue pastel of the stockings. This is a visual gesture of confidence, although, at the same time, its very looseness could suggest that the earth is unraveling around figures who, we could be forgiven for assuming, are the last representatives of humankind. Degas was never by nature pessimistic or cruel enough to explore this theme further, certainly not in works intended for exhibition or publication. Therefore, he must have drawn *The Bathers* for his own purposes. Since he sent it to his framer for mounting, we can assume that he considered the drawing to be complete, one he would never turn into a pastel. Perhaps it is an allegory we

cannot decipher. It was left to an artist of the next generation—Matisse—to perceive humanity arising out of such an unpromising, primordial world and achieving a state of bliss.

In many of his last works, Degas seemed torn between the artificiality of his own creation and reality—each much stronger than in the idiosyncratic *Bathers*, and the total far less specu-lative. This is true of Chicago's *Woman Drying Her Neck* (pl. 34; detail p. 67), along with the works related to it, which include one piece of sculpture. The wax statue, usually but inaccu-rately called *Woman Arranging Her Hair*, shows a nude female, her body stocky but her flesh lovingly modeled, her hair so generous and heavy that the artist built an armature alongside the statue to support it, as shown in a photograph taken of the wax not long after Degas's death (fig. 17). From everything we know about Degas's methods, he would have continued his practice of working from a model posing uncomfortably in his studio, as he had done for his bathers shown in the 1886 exhibition; and he would have continued to do so for the wax, the pastels, and the drawings of this figure. Nevertheless, although we cannot be certain that the sculpture preceded *Woman Drying Her Neck*, it does allow us to see the alternative angles from which Degas might have elected to draw the figure from the model. Undoubtedly, he

chose the back for its clarity and energy. In the pastel, he exaggerated the arc of the spine, curving it more to the left, and he revealed more of the head and neck, giving the body a greater physical force. Obviously, he could not use an armature to emphasize the weight of the hair, so he chose to draw it in luxuriant red pastels instead.

In several other compositions, Degas set bathers against a landscape—a stream and river-bank, with a glimpse of dramatic tree trunks—more indulgent toward human pleasures than the background of *The Bathers*. Certainly, this figure in itself represents continuity, not only in Degas's own work but in the history of the nude in art. The artist also used it to assert his convic-tion of the mastery of mind over the body, as the model responds with almost excessive energy to a routine task.

The Chicago pastel is not set in a landscape but in a domestic environment, an interior that has nearly become an abstraction. There is no indication of the structure of the room and little suggestion of its furnishings, except for a vague shape, which may be an overstuffed chair, at the left, and four swaths of color suspended like draperies from the ceiling. Although the space is indeterminate, it is also claustrophobic, threat-ening to smother us as well as the bather. The four panels of colored fabric seem to fill the interior, all so richly worked in pastel that it is

We see her energy expressed as an elemental force that the intensity of the colored fabrics finally cannot subdue.

"this famous stuff" in a work he was drawing on tracing paper pinned to a cardboard support. This garment could easily have inspired the curtain at the right in *Woman Drying Her Neck*, although Moreau-Nélaton's remarks suggest that Degas would have used actual materials—draperies, a greenish-white towel, and some other, indefinable fabrics on the floor—just as he would have used actual models to depict the human figure.

The extraordinarily rich texture and hue of this work remind us of the more romantic side of Degas, the aspect of his personality that made him willing, in 1892, to pay nine hundred francs—a very large sum at the time—for a handsome English edition of *The Thousand and One Nights*, which he said made him happy, although he admitted that it was a joke that he could not read it himself. In this pastel, we participate in that romanticism, sharing the artist's pleasure in selecting sticks of pastel for their color, and following the movements with which he applied them—almost a dance in itself. The panels in the background—one multicolored, the second red, and the third blue—are opulent, but they lack the dynamism of the orange curtain at the right, which seems to have pulled itself aside to reveal the figure, its folds and strange, black shadows adding a blatantly theatrical note to the whole. The drapery's light-orange color extends

almost impossible to detect with a naked eye the complex layers of strokes that form them. Degas had always been attracted by fabrics and worked with them lovingly, as we have seen in pastels such as *Retiring* (pl. 26) and *The Morning Bath* (pl. 30); and this affection grew with the years. When Moreau-Nélaton visited Degas in 1907, the artist immediately warned him not to touch a salmon-pink dressing gown placed over a chair, because he was using what the critic called

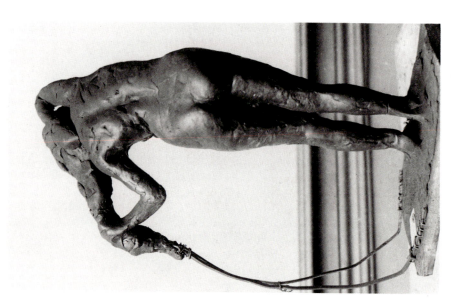

17. *Woman Arranging Her Hair*, 1900–10. Wax and other materials; h. 46.4 cm. Collection of Mr. and Mrs. Paul Mellon, Upperville, Virginia. Photograph, c. 1917.

throughout the image, building up seductively through the nude's creamy skin—where it is enhanced by other orange tones, in addition to yellows, greens, and fawns—and triumphs as it reaches such a rich depth in the magnificent red hair. The greenish-white towel with ragged edges, which the bather lifts to her neck, is so opaque and unbroken that it dramatizes the central axis and the power concentrated in limbs and hair. We see her energy expressed as an elemental force that the intensity of the colored fabrics finally cannot subdue.

We cannot claim that *Woman Drying Her Neck* is the consummation of the career of Edgar Degas; we cannot even prove with certainty its chronological relationship to other works of this period, such as *After the Bath (Woman Drying Her Feet)* or *The Bathers.* Curiously, none of the works connected with it seem to have been sold by Degas, either to Durand-Ruel or, alternatively, to Vollard, who had more enthusiasm for the artist's extreme, late art. After Degas's death, some were in his studio and others entered the possession of a nephew or niece, presumably as a result of the division of some of the contents of his studio among family members. *Woman at Her Toilette* is a work in which artifice and the actuality of the world he perceived, both so important to him, creatively converge. Although the flickering colors of the background seem about to consume the bather like some inferno, in actual fact she remains compellingly and forcefully intact.

The late work of Degas never built up to a crescendo, to the magnificent finales achieved by Monet, with his paintings of water lilies, and by Cézanne, with his large bathers and his last images of Mont Ste.-Victoire. There was never that apparently logical and inevitable progression in Degas's oeuvre. In fact, after he died, in 1917, and the contents of his studio were put up for sale, the four auctions of his paintings, pastels, drawings, prints, and counter-proofs bewildered the public. This surprise was not only because of the late works, which many today still find incomprehensible, but also by the apparent disorder of the production of his whole career. Even early paintings, such as *The Bellelli Family* (fig. 4), were unfamiliar; in fact, this now-famous canvas was published for the first time in the sale catalogue. (The French government was, however, astute enough to buy it before the sale itself, for the high price of three hundred thousand francs.) Degas had never structured his career with public recognition in mind. As discussed, he helped organize only one solo exhibition. It is only too probable that he was by disposition too cynical to have thought of working toward a triumphant end. In any case, nature intervened through his bad eyesight, which ultimately left him blind. Instead of a

time. It was bought by Mrs. Havemeyer, who had been a faithful collector of his works for some thirty-five years. When Degas was asked, after the auction, how he felt about the result, with characteristic cynicism, he made the famous reply: "Like the horse who has won the race and is given some oats." A mystique built up around Degas. Some Parisians, like Fernande Olivier, Picasso's early mistress (who, it has recently been discovered, visited Degas in his studio), as well as foreign artists, were anxious to meet the artist.

Blind and old, Degas was recognized (at least in Montmartre) for his long, white hair and beard, which was often remarked to be like Homer's. His presence gave the district a particular aura. The English satirist and caricaturist Max Beerbohm wrote: "Of all the great men whom I have merely seen, the one who impressed me most was Degas." Beerbohm recalled that a friend had pointed up to a high window, "and there, in the distance, were the head and shoulders of a gray-bearded man in a red beret, leaning across the sill. . . . There he was, is, and will always be for me, framed." With more than ninety works by this extraordinary artist in its collections, The Art Institute of Chicago, although far from Montmartre, has become another enduring frame in which Degas is, and always will be, found.

18. Sacha Guitry (French; 1885–1947). *Degas in the Streets of Paris.* 1912/14. Photograph, modern print. Bibliothèque nationale, Paris.

major masterpiece summing up his career, then, we have a plethora of drawings, pastels, and sculpture made with seemingly ephemeral materials such as tracing paper or wax. These late works, in which we may detect the artist's infirmities, can provoke frustration because they do not fall into a natural or easily detectable order. But even in the humblest sketches, we are never able to ignore the intelligence and the passion of Edgar Degas.

Degas achieved something close to universal fame in 1912, when his *Dancers Practicing at the Bar* (1876–77; The Metropolitan Museum of Art, New York) was sold in Paris for nearly five hundred thousand francs, the highest price fetched at auction for the work of a living artist up to that

Plates

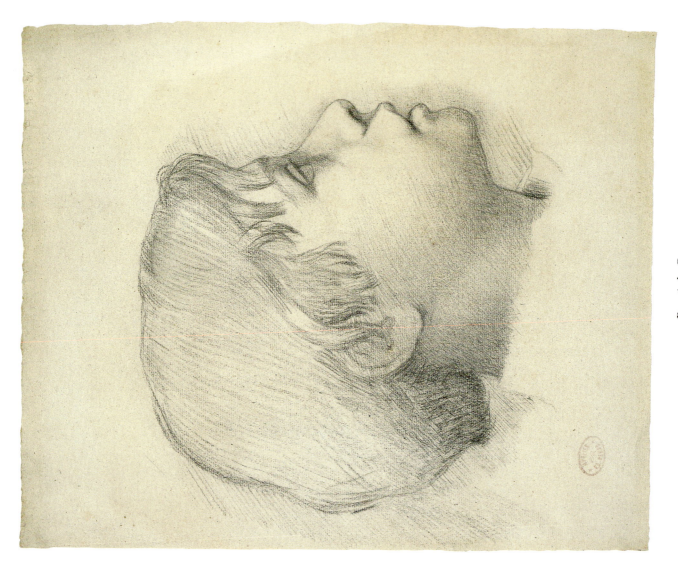

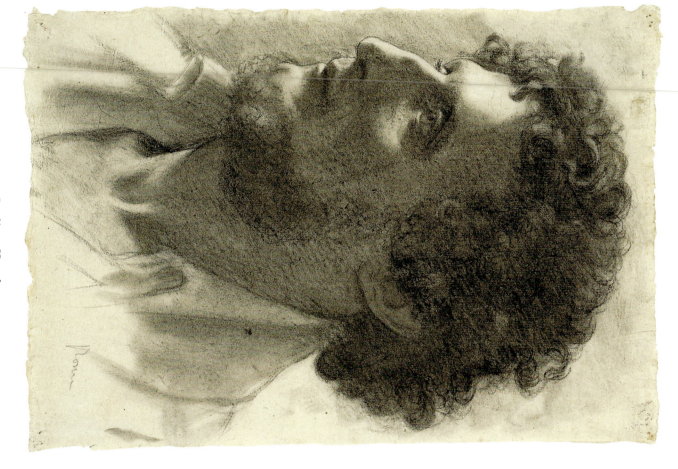

2. *Italian Head*

c. 1856

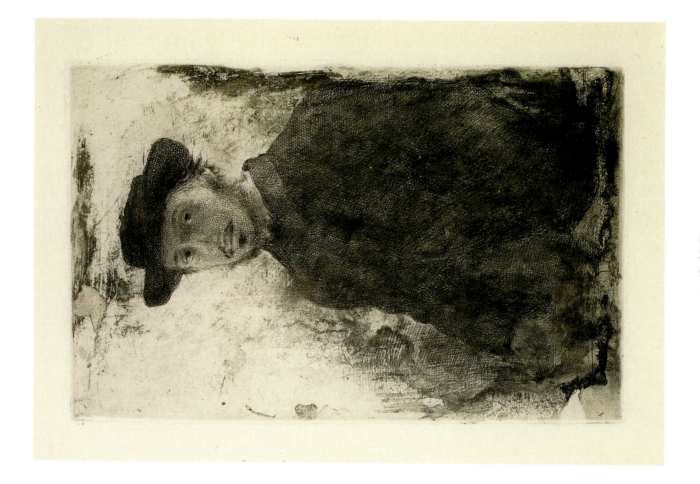

3. Self-Portrait
1857/61

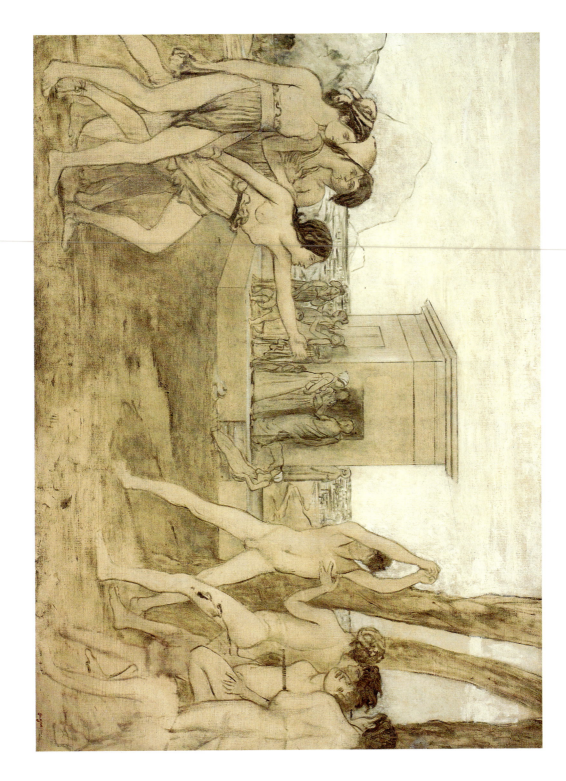

4. *Young Spartans*
c. 1860

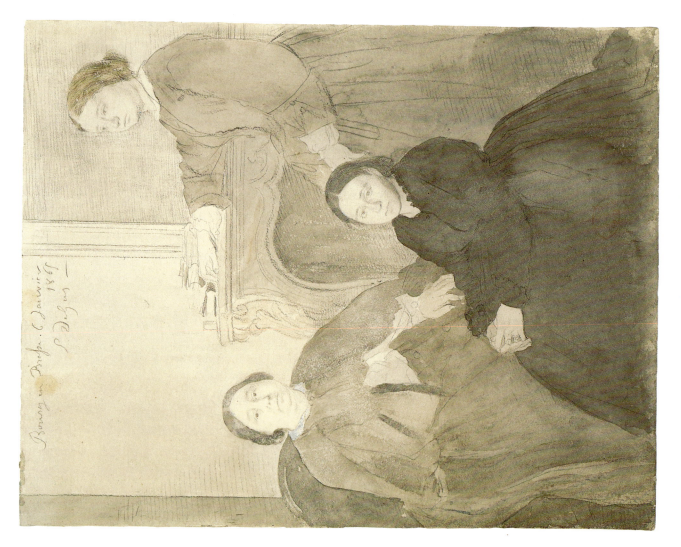

5. *Mme Michel Musson and Her Daughters Estelle and Désirée*
1865

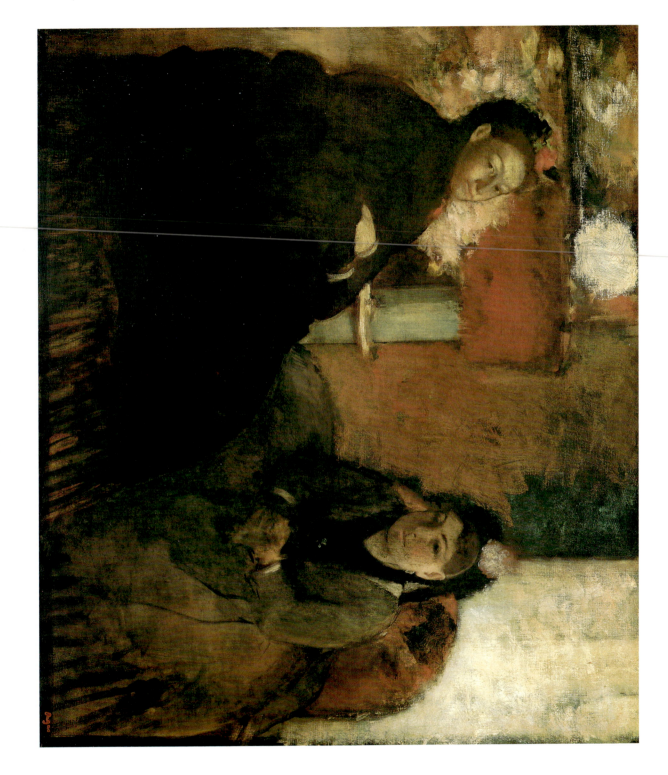

6. *Portrait of Mme Lisle and Mme Loubens*

1866/70

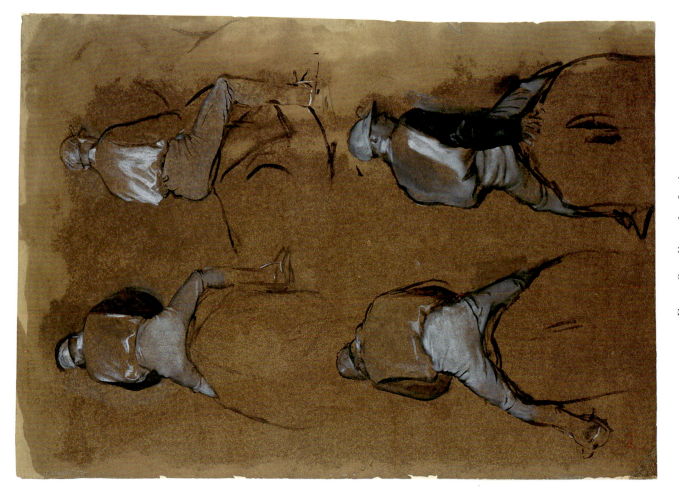

7. Four Studies of a Jockey
1866/68

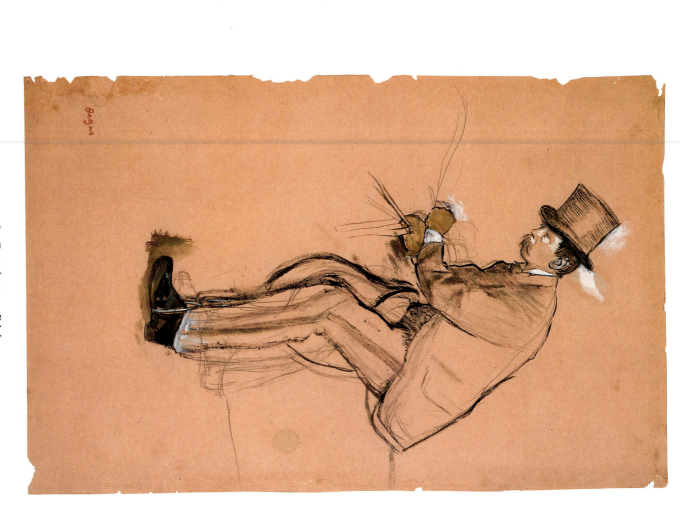

8. Gentleman Rider
1866/73

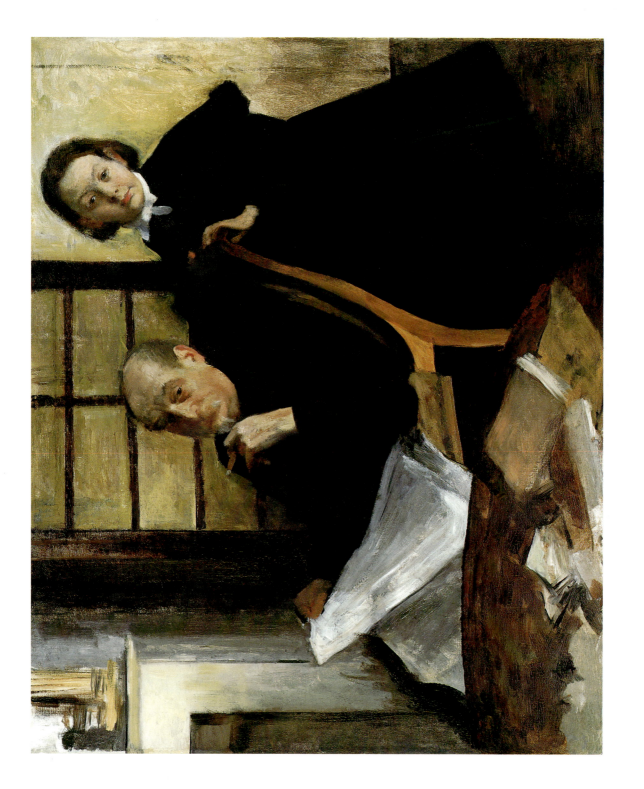

9. Uncle and Niece (Henri Degas and His Niece Lucie Degas)
1875

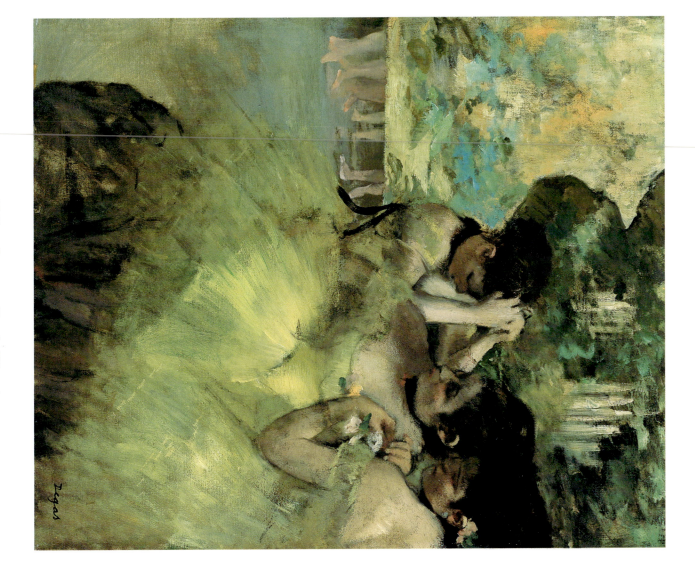

10. Yellow Dancers (In the Wings)

1874/76

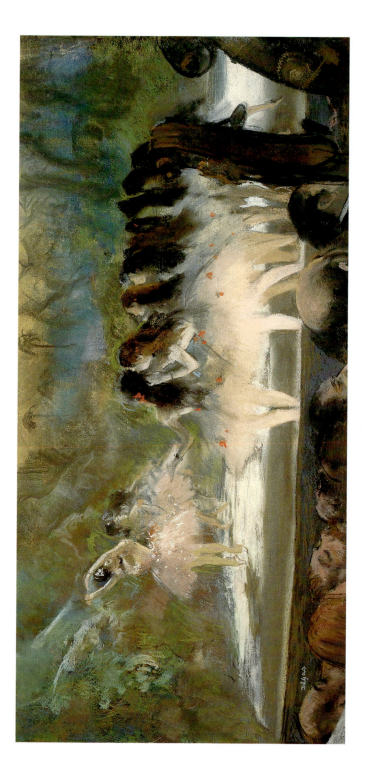

11. Ballet at the Paris Opéra
1 8 7 6 / 7 7

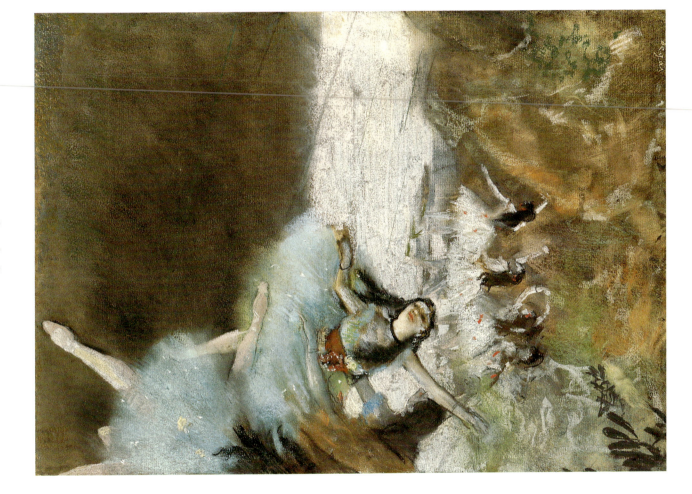

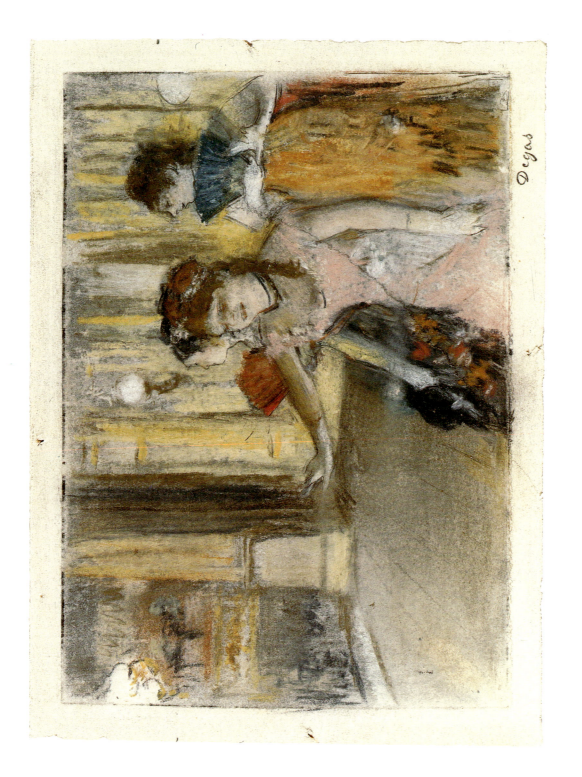

Degas

13. Singers on the Stage
1877/79

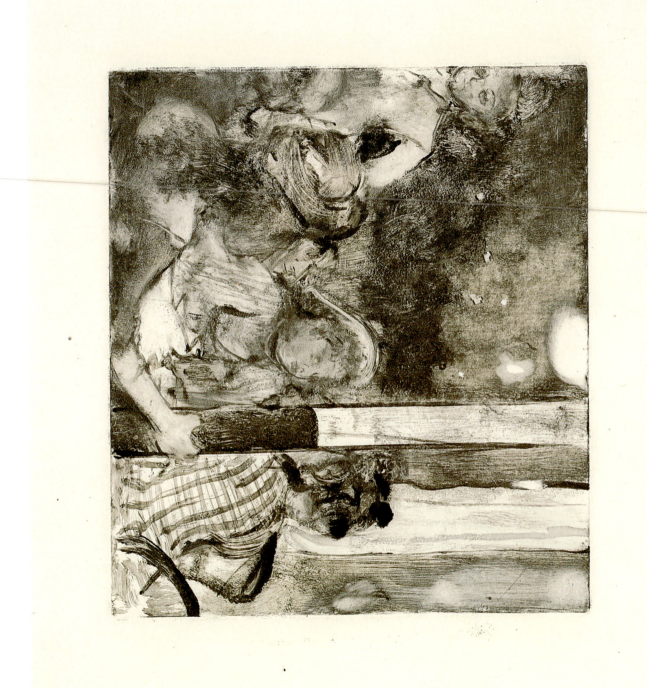

14. Women on the Terrace of a Café in the Evening

1876 / 77

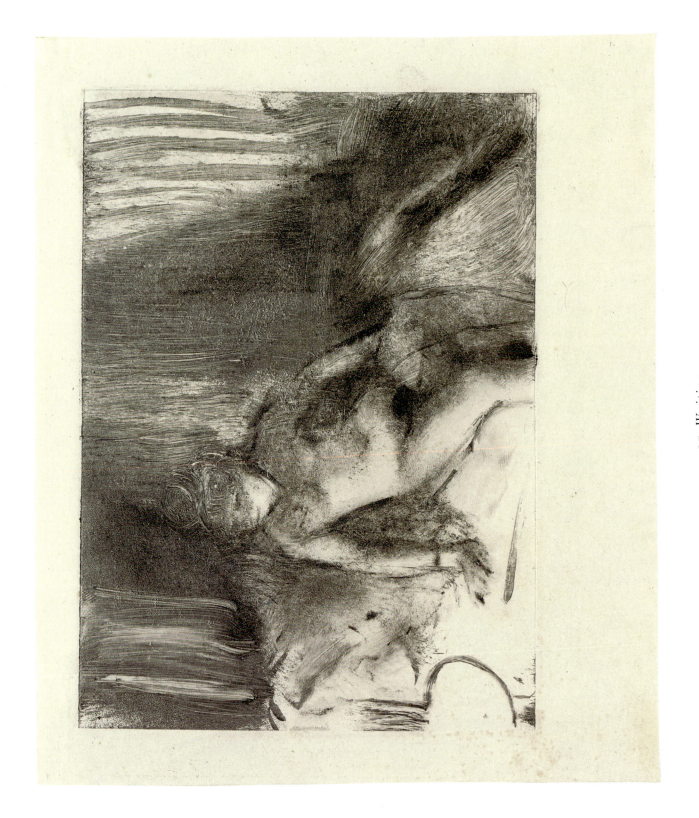

15. Waiting

c. 1879

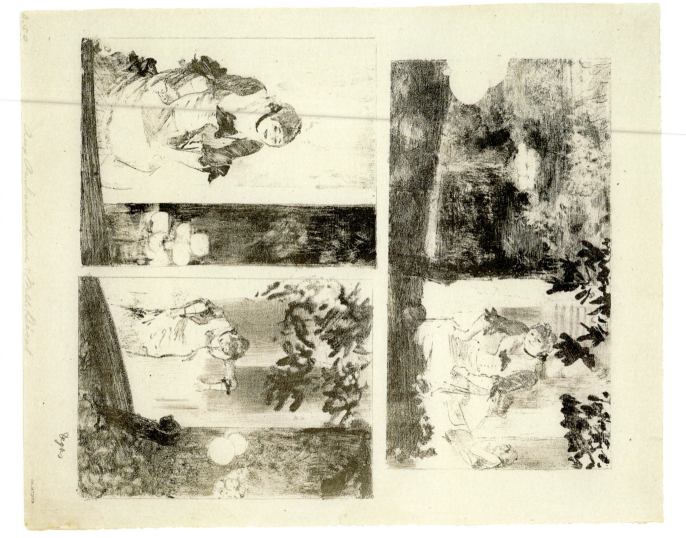

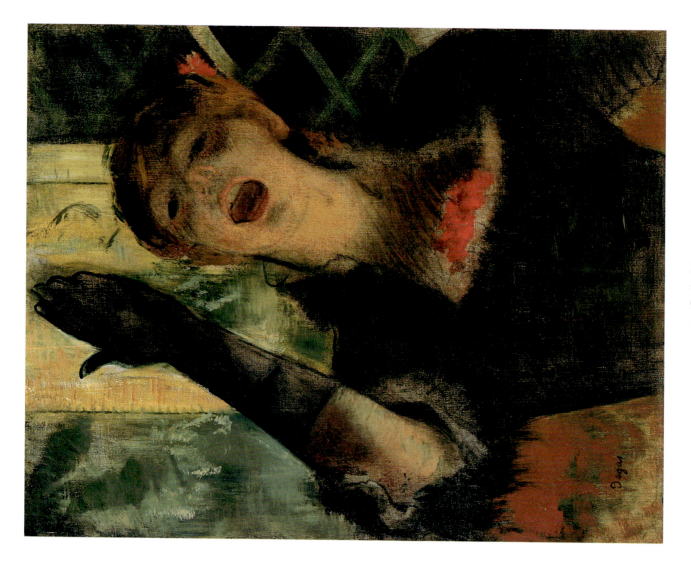

17. Café Singer

c. 1879

19. Portrait of Mme Dietz-Monnin
c. 1879

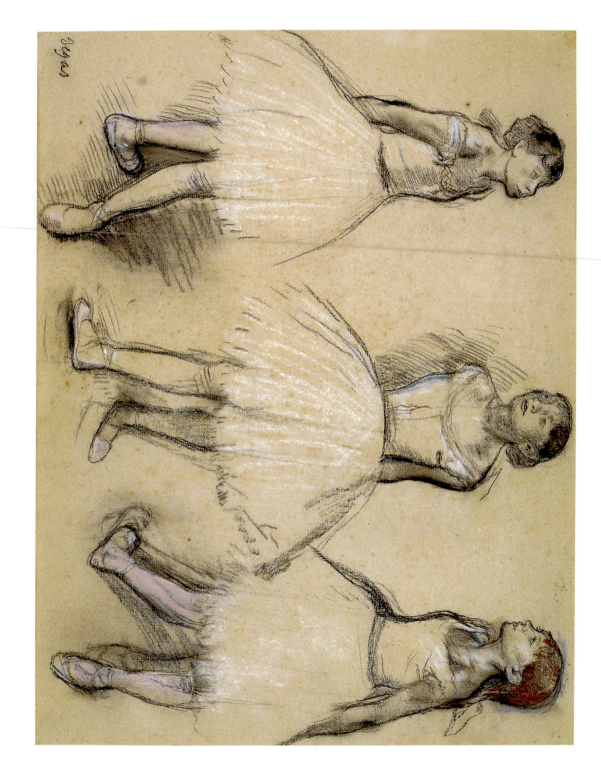

20. *Three Studies of a Dancer in Fourth Position*
1879/81

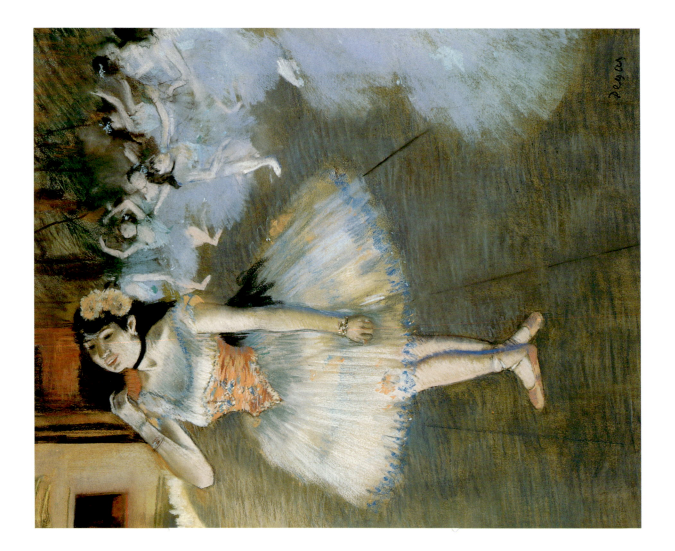

21. The Star
c. 1880

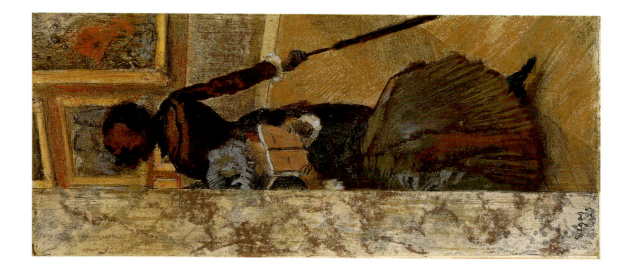

23b. Mary Cassatt in the Painting
Gallery of the Louvre
1885

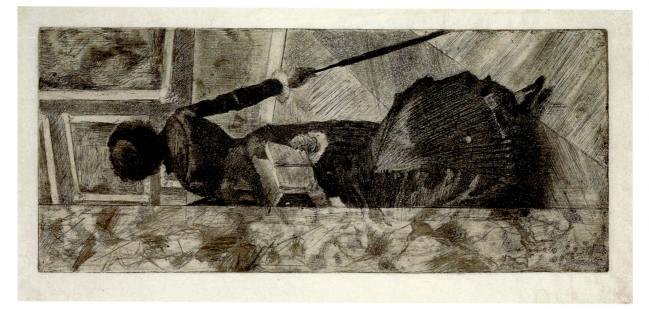

23a. Mary Cassatt in the Painting
Gallery of the Louvre
c. 1879/80

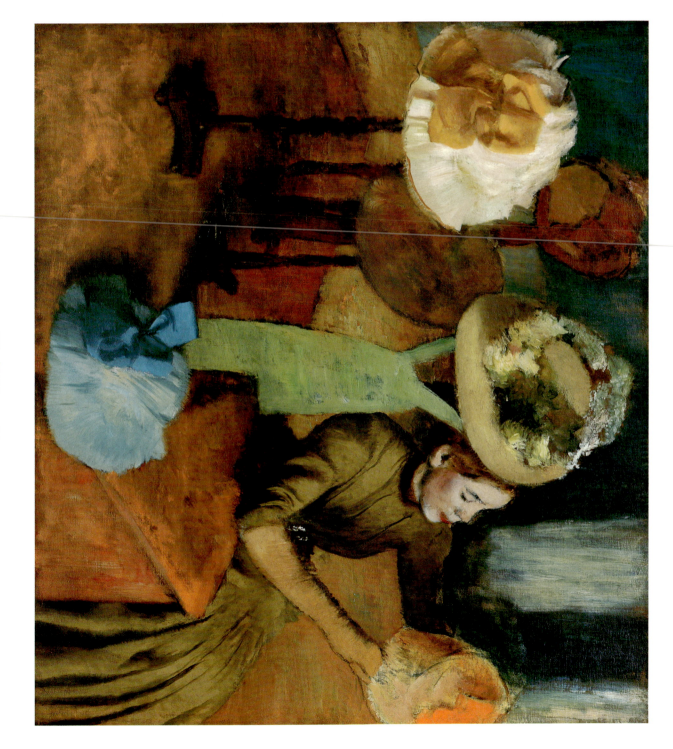

25. Harlequin
1885

26. *Retiring*
c. 1883

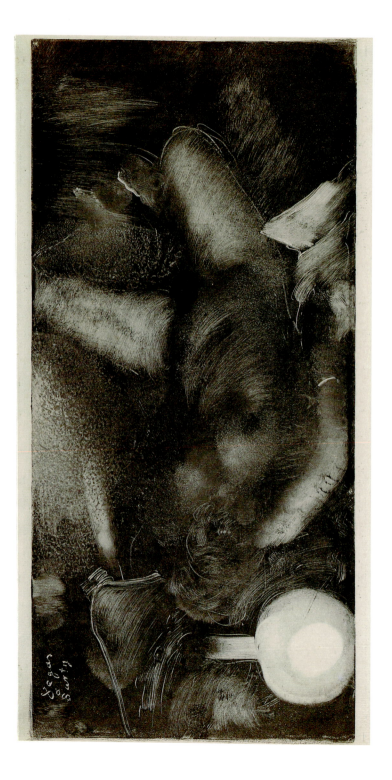

27. *Female Nude Reclining on Her Bed*
1880 / 85

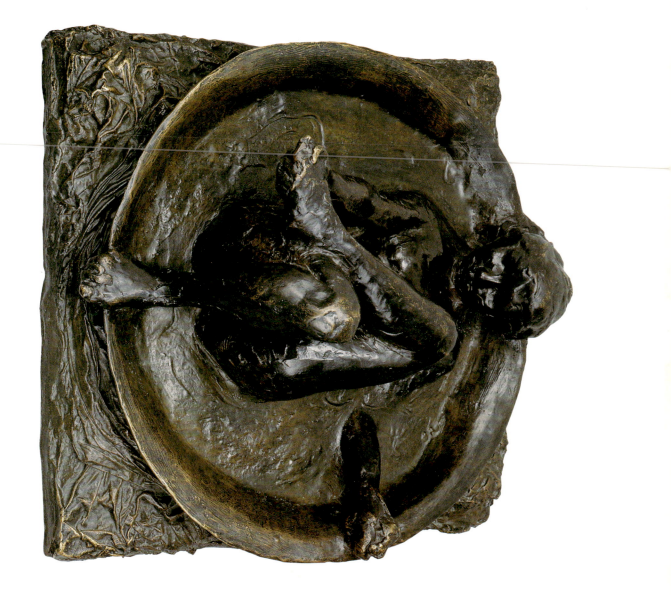

28. *The Tub*
1889

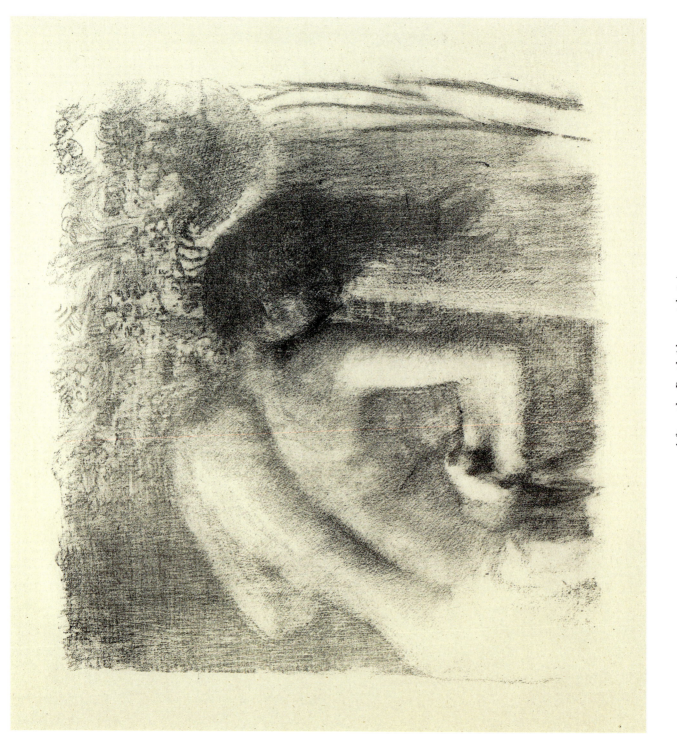

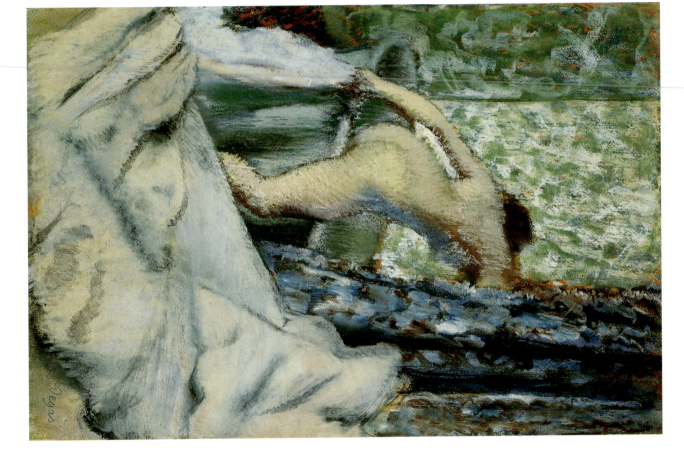

30. *The Morning Bath*
1890/96

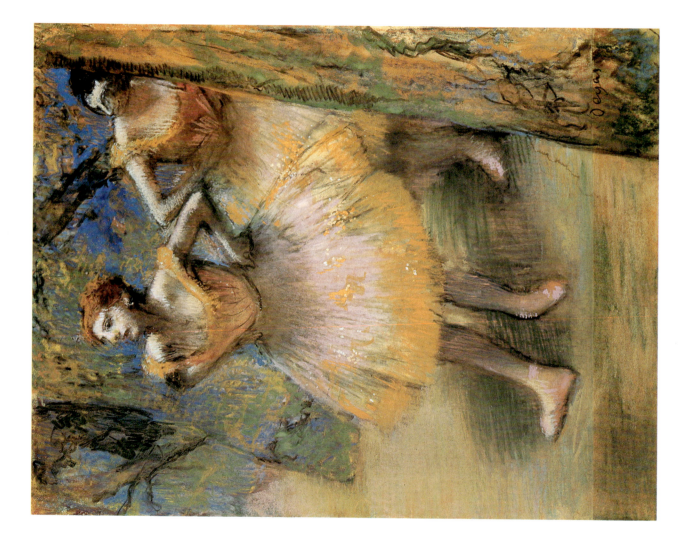

31. Two Dancers
1890/98

32. *After the Bath (Woman Drying Her Feet)*
c. 1900

33. The Bathers
1895/1905

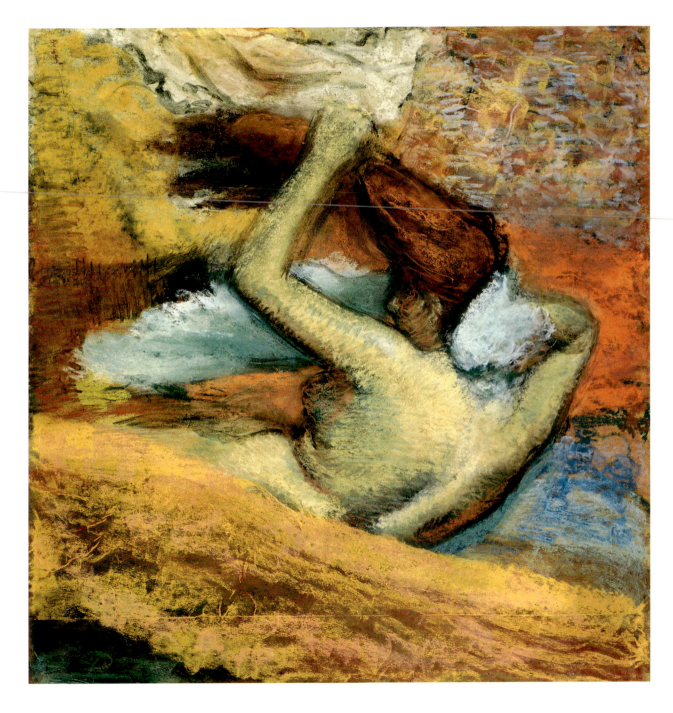

34. *Woman Drying Her Neck*
1900 / 1905

Checklist

1. *René de Gas*
c. 1855
Black chalk on ivory laid paper; 34.6 x 28 cm
Helen Regenstein Collection, 1961.792
Ill. p. 72

2. *Italian Head*
c. 1856
Charcoal with stumping, heightened with
touches of white chalk, on ivory wove paper;
38.4 x 26 cm
Margaret Day Blake Collection, 1945.37
Ill. p. 73

3. *Self-Portrait*
1857/61
Etching on ivory laid paper, third state of four;
23.2 x 14.3 cm (plate), 32.4 x 23.1 cm (sheet)
Joseph Brooks Fair Collection, 1932.1294
Ill. p. 74, detail p. 15

4. *Young Spartans*
c. 1860
Oil on canvas; 97.4 x 140 cm
Charles H. and Mary F. S. Worcester Fund,
1961.334
Ill. p. 75

5. *Mme Michel Musson and Her Daughters
Estelle and Désirée*
1865
Watercolor, with touches of charcoal and
brush and red-chalk wash, heightened with
touches of white gouache, over graphite, on
cream wove paper; 35 x 26.5 cm
Margaret Day Blake Collection, 1949.20
Ill. p. 76

6. *Portrait of Mme Lisle and Mme Loubens*
1866/70
Oil on canvas; 84 x 96.6 cm
Gift of Annie Laurie Ryerson in memory
of Joseph Turner Ryerson, 1953.335
Ill. p. 77

7. *Four Studies of a Jockey*
1866/68
Brush and black gouache, with white and
brown oil paint, on brown wove paper
discolored with *essence*, laid down on cream
card; 45 x 31.5 cm
Mr. and Mrs. Lewis Larned Coburn
Memorial Collection, 1933.469
Ill. p. 78

8. *Gentleman Rider*
1866/73
Brush and black gouache, with touches
of white and brown oil paint, over graphite,
on pink wove paper, laid down on board;
44 x 28 cm
Gift of Mrs. Josephine Albright, 1967.240
Ill. p. 79

9. *Uncle and Niece (Henri Degas and His Niece
Lucie Degas)*
1875
Oil on canvas; 99.8 x 119.4 cm
Mr. and Mrs. Lewis Larned Coburn
Memorial Collection, 1933.429
Ill. p. 80, detail p. 27

10. *Yellow Dancers (In the Wings)*
1874/76
Oil on canvas; 73.5 x 59.5 cm
Gift of Mr. and Mrs. Gordon Palmer, Mrs.
Bertha P. Thorne, Mr. and Mrs. Arthur M.
Wood, and Mrs. Rose M. Palmer, 1963.923
Ill. p. 81

11. *Ballet at the Paris Opéra*
1876/77
Pastel over monotype on cream laid paper;
35.2 x 70.6 cm (plate), 35.9 x 71.9 cm (sheet)
Gift of Mary and Leigh Block, 1981.12
Ill. p. 82, detail p. 33

12. *On the Stage*
1876/77
Pastel and *essence* over monotype on cream
laid paper, laid down on board, second of
two impressions; 59.2 x 42.5 cm
Potter Palmer Collection, 1922.423
Ill. p. 83, detail frontispiece

13. *Singers on the Stage*
1877/79
Pastel over monotype on ivory wove
paper, laid down on board, second of two
impressions; 12 x 16.9 cm (plate),
13.8 x 18.2 cm (sheet)
Bequest of Mrs. Clive Runnells, 1977.773
Ill. p. 84, detail p. 106

14. *Women on the Terrace of a Café in the Evening*
1876/77
Monotype on ivory wove paper; 27 x 29.8 cm
(image), 46.5 x 54.9 cm (sheet)
Through prior bequest of Mr. and Mrs.
Martin A. Ryerson Collection, 1990.77.1
Ill. p. 85

15. *Waiting*
c. 1879
Monotype on grayish-white wove paper;
10.9 x 16.1 cm (plate), 16.3 x 18.8 cm (sheet)
Gift of Mrs. Charles Glore, 1958.11
Ill. p. 86

16. *Mlle Bécat at the Ambassadeurs*
1876/78
Lithograph transferred from monotypes, on
ivory wove paper, only state; 29.3 x 24.5 cm
(image), 35.1 x 27.5 cm (sheet)
Clarence Buckingham Collection, 1952.235
Ill. p. 87

17. *Café Singer*
c. 1879
Oil on linen; 53.5 x 41.8 cm
Gift of Clara Lynch, 1955.738
Ill. p. 88

18. *Portrait after a Costume Ball (Portrait of Mme Dietz-Monnin)*
1879
Distemper, with metallic paint and pastel, on
fine-weave canvas, prepared with a glue size;
85.5 x 75 cm
Joseph Winterbotham Collection, 1954.325
Ill. p. 89

19. *Portrait of Mme Dietz-Monnin*
c. 1879
Graphite on ivory laid paper; 24 x 22 cm
Gift of Mrs. Gilbert W. Chapman in memory
of Charles B. Goodspeed, 1947.810
Ill. p. 90

20. *Three Studies of a Dancer in Fourth Position*
1879/81
Charcoal and pastel, with stumping, and
touches of brush and black wash, on
grayish-tan laid paper with blue fibers
(discolored from pinkish blue), laid down
on gray wove paper; 48 x 61.6 cm
Bequest of Adele R. Levy, 1962.703
Ill. p. 91, detail p. 43

21. *The Star*
c. 1880
Pastel on cream wove paper, edge mounted
on board; 73.3 x 57.4 cm
Bequest of Mrs. Diego Suarez, 1980.414
Ill. p. 92, detail p. 49

22. *Dancer Bending Forward*
1881
Charcoal, with stumping, heightened with
white and yellow pastel with stumping,
on blue laid paper, ruled with charcoal;
46 x 30.4 cm
Mr. and Mrs. Martin A. Ryerson Collection,
1933.1230
Ill. p. 93

23a. *Mary Cassatt in the Painting Gallery of the Louvre*
c. 1879/80
Etching, aquatint, drypoint, and *crayon électrique* on grayish-ivory wove paper,
sixteenth state of twenty; 30.5 x 12.6 cm
(plate), 34 x 17.5 cm (sheet)
Gift of Walter S. Brewster, 1951.323
Ill. p. 94

23b. *Mary Cassatt in the Painting Gallery of the Louvre*
1885
Pastel over etching, aquatint, drypoint, and *crayon électrique*, on tan wove paper; 30.5 x 12.7 cm (plate), 31.3 x 13.7 cm (sheet)
Bequest of Kate L. Brewster, 1949.515
Ill. p. 94, detail p. 71

24. *The Millinery Shop*
1884/90
Oil on canvas; 100 x 110 cm
Mr. and Mrs. Lewis Larned Coburn Memorial Collection, 1933.428
Ill. p. 95, detail p. 53

25. *Harlequin*
1885
Pastel on cream laid paper, pieced and laid down on board; 64.5 x 57.8 cm (maximum dimensions)
Bequest of Loula D. Lasker, 1962.74
Ill. p. 96

26. *Retiring*
c. 1883
Pastel, with stumping, on cream wove paper, laid down on board; 36.4 x 43 cm
Bequest of Mrs. Sterling Morton, 1969.331
Ill. p. 97

27. *Female Nude Reclining on Her Bed*
1880/85
Monotype on ivory laid paper; 19.9 x 41.3 cm (plate), 22.1 x 41.8 cm (sheet)
Clarence Buckingham Collection, 1970.590
Ill. p. 98

28. *The Tub*
1889
Bronze cast after wax original, foundry no. 26; 47 x 42 cm
Wirt D. Walker Fund, 1950.114
Ill. p. 99

29. *After the Bath (large plate)*
1891–92
Lithograph on cream laid paper, fifth state of five; 36 x 31.3 cm (image), 43.1 x 48.5 cm (sheet)
Joseph Brooks Fair Collection, 1932.1332
Ill. p. 100

30. *The Morning Bath*
1890/96
Pastel on cream wove paper, laid down on board; 66.8 x 45 cm
Potter Palmer Collection, 1922.422
Ill. p. 101, detail p. 59

31. *Two Dancers*
1890/98
Pastel on cream wove paper, pieced and laid down on board; 70.5 x 53.6 cm (maximum dimensions)
Amy McCormick Memorial Collection, 1942.458
Ill. p. 102

32. *After the Bath (Woman Drying Her Feet)*
c. 1900
Charcoal and touches of red, light-blue,
and ocher pastel, with stumping, on tracing
paper, pieced and laid down on cardboard;
56.7 x 40.8 cm (maximum dimensions)
Gift of Mrs. Potter Palmer, 1945.34
Ill. p. 103

33. *The Bathers*
1895 / 1905
Pastel and charcoal, with stumping and
burnishing, on tracing paper, pieced and
laid down on board; 104.6 x 108.3 cm
(maximum dimensions)
Gift of Nathan Cummings, 1955.495
Ill. p. 104

34. *Woman Drying Her Neck*
1900 / 1905
Pastel and charcoal, with stumping and
burnishing, on tracing paper, pieced and
laid down on cream wove paper, edge
mounted on cardboard; 74.6 x 71.3 cm
(maximum dimensions)
Bequest of Mr. and Mrs. Martin A. Ryerson,
1937.1033
Ill. p. 105, detail p. 67

Selected Bibliography

Much of this text is based on research by Richard R. Brettell and Suzanne Folds McCullagh for their catalogue accompanying a 1984 exhibition of works by Degas in the Art Institute's collection, for which this author has been most grateful. In addition to it, listed here are basic catalogues raisonnés and research since 1984 that have some bearing on the works chosen for the present publication.

Boston, Museum of Fine Arts. *Edgar Degas: The Painter as Printmaker*. Exh. cat. by Sue Welsh Reed and Barbara Stern Shapiro, with contributions by Clifford S. Ackley and Roy L. Perkinson, and an essay by Douglas W. Druick and Peter Zegers. 1984.

Cambridge, Mass., Fogg Art Museum, Harvard University. *Degas Monotypes*. Exh. cat. by Eugenia Parry Janis. 1968.

Chicago, The Art Institute of Chicago. *Degas in The Art Institute of Chicago*. Exh. cat. by Richard R. Brettell and Suzanne Folds McCullagh. 1984.

Degas, Edgar. *Degas Letters*. Ed. Marcel Guérin, trans. Marguerite Kay. Oxford, 1947.

Lemoisne, Paul André. *Degas et son oeuvre*. 4 vols. Paris, 1946–49; reprint, New York, 1984.

London, National Gallery. *Degas: Beyond Impressionism*. Exh. cat. by Richard Kendall. 1996.

Loyrette, Henri. *Degas*. Paris, 1991.

Ottawa, National Gallery of Canada, et al. *Degas*. Exh. cat. by Jean Sutherland Boggs, Henri Loyrette, Michael Pantazzi, and Gary Tinterow, with an essay by Douglas W. Druick and Peter Zegers. 1988.

Pingeot, Anne. *Degas Sculptures*. Photographs by Frank Horvat. Paris, 1991.

Reff, Theodore. *The Notebooks of Edgar Degas*. 2 vols. London, 1976; reprint, New York, 1985.